ELLIPSIS
Volume 1

SHIFTING HORIZONS

D1501407

ELLIPSIS

Volume 1

SHIFTING HORIZONS

WOMEN'S LANDSCAPE PHOTOGRAPHY NOW

Edited by Liz Wells,
Kate Newton & Catherine Fehily

I.B.Tauris *Publishers*

LONDON • NEW YORK

Published in 2000 by I.B.Tauris & Co Ltd
Victoria House, Bloomsbury Square, London WC1B 4DZ
175 Fifth Avenue, New York NY 10010
www.ibtauris.com

In the United States of America and in Canada distributed by
St Martins Press, 175 Fifth Avenue, New York NY 10010

Paperback ISBN 1 86064 635 20

A full CIP record for this book is available from the British Library
A full CIP record for this book is available from the Library of Congress

Library of Congress catalog card: available

Designed and typeset by Axis Design, Manchester
Printed and bound in Spain

COVER IMAGE: 'Prospect of the Schloss at Baden-Baden'
from Kate Mellor, *In the Steps of Robert Pinnacle*
BACKCOVER IMAGE: Åsa Andersson, *Writing Water in its Absence*

Unless stated otherwise, all images © individual authors

TEXTS		PHOTOGRAPHS

FOREWORD

Catherine Fehily & Kate Newton

IRIS – *The Women's Photography Project, at Staffordshire University, exists in order to recognize the valuable contribution made by women practitioners to the development of photographic theory and practice, through research into and promotion of the work of contemporary women photographers and women writing on photography.*

IRIS aims to:

- *promote the work of women in photography through exhibitions, events and publications*
- *document women's photography and writing on photography*
- *provide a networking resource*
- *foster an awareness of women's practice.*

Since the establishment of IRIS in 1994 these aims have been pursued through a series of exhibitions, events and publications, including a national conference in 1995 and a website, *Ariadne*: http://www.staffs.ac.uk/ariadne. The exhibitions, 'Touched by Light' (1994), 'Resourceful Women' (1994), 'City Limits' (1996), 'In Spite of Appearances' (1997) and 'Child's Play' (1998) dealt with a variety of themes and successfully presented the work of IRIS members to a wide audience. During these years, the resource – a collection of slides, artists' statements, written material and biographical information – has grown steadily so that, from representing around one hundred women in 1994, it now contains the work of three times that many.

We were convinced from the outset that this collection would always form the heart of the organization, and were determined to keep it alive and growing through research and development. For this reason we adopted the word 'resource' in preference to 'archive', as we felt that the latter implied a kind of stasis. Our intuitive sense of the importance of the resource has been vindicated by the productive use that historians and academics have made of it. *Nexus: Theory and Practice in Contemporary Women's Photography*, a series of six interdisciplinary volumes which addressed imagery drawn exclusively from the IRIS resource, was edited by Dr Marsha Meskimmon and published between 1997 and 1999.

While the *Nexus* series was essentially theoretical in nature, it demonstrated the potential of the resource as a rich source of material for the exploration of ideas about photography, and of the book form as an effective way of achieving IRIS' aims. We decided to concentrate our efforts on the use of the resource for research and publication; a decision which coincided, opportunely, with our meeting Philippa Brewster, of I.B.Tauris. The first outcome of this new policy was *I Spy – Representations of Childhood*, which grew out of the 'Child's Play' exhibition, and which we edited with the invaluable collaboration of Jane Fletcher. Published by I.B.Tauris in 2000, *I Spy* provided an example of the way in which the thread of a single theme could usefully be traced through the resource. It offered us a model for the design of a book where images were presented in the context of words, without being relegated to a secondary, illustrative role.

ELLIPSIS

ellipsis, **ellipse**, *n. Omission from sentence of words needed to complete construction or sense; omission of sentence at end of paragraph; set of three dots etc. indicating such omission.*

The Concise Oxford Dictionary

We had, for some time, been looking for a framework within which to examine the wealth of material available to us, and a way of reflecting the richness and complexity of the resource. *I Spy* seemed to offer a solution; if we could trace a number of different threads through the collection, in a similar way, we might begin to approach that extremely difficult, almost unaskable, question: do women see and represent the world in any definable 'feminine' way? It does not seem an unreasonable question to ask, given that women share a physical and cultural experience (with all the historical, geographical and social differences acknowledged). But which threads? In what ways are images grouped? Which are the dominant themes? This last question led us, inexorably, to the categories, or 'genres', inherited from painting in which pictures have been grouped throughout the history of photography, – genres, based on themes which have indeed been dominant, and which have been dominated by men. We decided to embark on an investigation of the ways in which women negotiate the traditions, conventions and theories accrued around the medium of photography. The rigid structure, or framework, for this enquiry would be provided by the (patriarchal) grid

of organization implied in five genres: landscape, portrait, still life, social realism and the nude. A series of five books would attempt to trace the threads of women's weaving in, through, around, against and beyond that structure. We decided to adopt the format of *I Spy*, in that the portfolios of images would be presented in parallel with the essays, and to invite men, as well as women, to write for the books, so that the context for the images would be broad and inclusive.

It is not our intention to attempt to answer the intensely problematic question raised above, but we have a hunch that women are operating, very productively and with great success, in the in-between spaces (the 'ellipses') of photographic history. In this spirit of speculation, and with the expert collaboration of Liz Wells, we searched the resource for work that seemed to belong within, or to respond to, the tradition of 'landscape'. We were amazed to discover how many (around 27%) of IRIS' members were working in this area, and fascinated to find that they unanimously reject any notion of a fixed, immutable or stable landscape. They deal, intuitively, with the world as process, where everything is fluid, transient and in momentum. They share Virginia Woolf's conviction that life is far from solid, that it is, in fact, shifting. The result is this first volume of *Ellipsis: – Shifting Horizons*.

Catherine Fehily and Kate Newton

INTRODUCTION:
BETWEEN SEEING AND KNOWING

Liz Wells

The sun had not yet risen. The sea was indistinguishable from the sky, except that the sea was slightly creased as if a cloth had wrinkles in it ...
Gradually the dark bar on the horizon became clear as if the sediment in an old wine-bottle had sunk and left the glass green.
Behind it, too, the sky cleared as if the white sediment there had sunk, or as if the arm of a woman couched beneath the horizon had raised
a lamp and flat bars of white, green and yellow spread across the sky like the blades of a fan. Then she raised her lamp higher and the air seemed to
become fibrous and to tear away from the green surface flickering and flaming in red and yellow fibres like the smoky fire that roars from a bonfire ...
Slowly the arm that held the lamp raised it higher and then higher until a broad flame became visible; an arc of fire burnt on the rim
of the horizon, and all round it the sea blazed gold. VIRGINIA WOOLF[1]

What contribution have women made to illuminating our relation with our environment? This collection of portfolios and essays about landscape includes contemporary work by eleven women photographers and seven writers. Addressing a diversity of themes the photographers explore the perimeters of vision, focusing on land, sea, environment. In effect, they test the boundaries of a genre which has been dominated by male perspectives throughout its long history. Water recurs often, as a potent symbol of fluidity, flow and flux. We are reminded of ways in which the rural is referenced in literature or inscribed in the domestic. Whether literal, rhetorical or metaphorical in her approach, each invites us to examine the construction of space and its mythologization, and, indeed, ways of seeing. Deploying a range of aesthetic strategies, our attention is drawn to fundamental affects of the environment we inhabit. Taken together the work testifies to ambiguity, uncertainty, transience, indeed, the speculations are as much about knowledge as they are about photography. Modes of expression range from historical (non-silver) processes to the use of new (digital)

technologies. We are invited to look at and enjoy the image, whilst simultaneously looking through it towards the implications of that which is being articulated.

The five portfolio sections are organized, loosely, according to themes: investigations, personal and cultural memory, urban constructs, journeys and histories. These themes interact throughout the book, resonating not only within and between the portfolios of work but also in relation to the written contributions. Determining the order of work, and which essays to put near which portfolios, involved taking into account visual juxtapositions as well as thematic links. Books are linear in construction; this forces a particular sense of order on the work, but the web of connections and provocations is potentially complex and haphazard. Despite the siting of essays beside particular portfolios, and the specific conjunctures of visual work, the collection should be enjoyed serendipitously.

The first three bodies of work indicate a range of responses to the environment in terms of ideas and visual strategies. Åsa Andersson creates images through water,

working with the immediate poetics of translucence and fluidity. Julia Peck invites us into direct engagement with the minutiae of our environment through her close-up images of the quarry face. Lou Spence photographs farmland, eschewing pictorialism for a more worrying realism intended to debunk myths of the picturesque. In terms of scale, aesthetic strategy and technique, each portfolio is distinct, but together they invite us to reconsider our feelings about our relationship with nature.

The second portfolio focuses our attention on memory, both subjective and collective, and on ways in which marks in the landscape reflect histories and trigger recollections which may not necessarily be reassuring. Gina Glover returns us to the formal garden, familiar from childhood, which she has re-examined as a pathway to memory. Sian Bonnell draws our attention to marks found on rocks by the sea, and to ways in which fossils, souvenirs and childhood toys reference centuries of history. Michelle Atherton and Sally Waterman offer a more urban, and disturbing, focus. Michelle Atherton photographs parks at night, conflating the appearance of

daylight with the presence of artificial light, thereby disorienting our sense of time. Referencing Virginia Woolf, Sally Waterman expresses the unease and alienation of everyday experience of the urban space. Liz Nicol and Su Grierson focus on our experience of space. Through collecting rubber bands dropped as the post is delivered daily, Liz Nicol traces patterns and congestions of communication, expressed abstractly through photograms. Su Grierson draws our attention to the experience of journeys, using video and video-stills to capture and express movement through space.

On what basis is landscape constructed? This is particularly addressed in the final portfolio section which includes Roshini Kempadoo's reminder that legacies of imperialism are marked as much in the preservation of the vistas of English country estates, built on the basis of economic exploitation of the colonies, as in contemporary global communications and power relations. Kate Mellor reminds us of particular histories, here, the decaying health spas, once designed as restorative places and social spaces for the European leisure classes.

'Landscape' is a cultural construct, an imaginary space which resonates through landscape gardening, parks, archaic sites considered of historic interest – such as Avebury or Stonehenge – through painting, photography, postcards and travelogues. The seven essays included here address recurrent concerns with aesthetics, land in relation to the self, memory, cultural histories, gender. Historically women have not taken a prominent place within the landscape tradition. Women look differently, refusing the more categorical strictures and disciplines of the genre, perhaps offering a more affective response to the environment as perceived and experienced. This is particularly indicated in the first essay: Roberta McGrath emphasizes the 'journey' which is life, a learning experience upon which children embark very young. This journey is one of learning and forgetting, of looking, and maybe seeing. The status of photography in relation to memory is further addressed in Martha Langford's discussion of work by Brenda Pelkey which challenges ways in which the photograph, however flawed as a token of memory, may nonetheless be taken as a stand-in for actual memory.

There is a key definitional distinction to be drawn between 'land' and 'landscape'. In principle, land is a natural phenomenon, although all land in Britain, has been subjected to extensive human intervention and, indeed, as David Bate notes, conceptualized in terms of 'beauty' through which, he argues, we aim to code and contain our relation with land. Likewise, Stevie Bezencenet suggests that ideologies associated with 'wilderness', in relation to the American West, interact with gender and identity and influence the language of 'landscape' to an extent that renders it difficult for women to find a new symbolic in terms of perception and representation of space.

Relatively few women artists have been formally employed as landscape artists, whether as painters or as photographers. This is not to say that women have not painted views. Women with leisure have been as susceptible to the picturesque as their male counterparts. However, sketches and watercolours thus produced are the legacy of an 'amateur', often aristocratic, leisure pastime. Furthermore, as Sue Swingler observes in her discussion of the late nineteenth and early twentieth centuries, photographs were made not for framing and hanging in public spaces but rather for inclusion in the family album. John Stathatos' discussion of women and landscape in Europe and his conclusion that women photographers in Europe have had only a conditional presence in landscape practices, further underlines the historical marginalization of women within the genre.

Photography portfolios included in this collection have been selected from a single source. As co-editor, I enjoyed working with Kate and Catherine, exploring the IRIS resource in some detail. In considering bodies of work, we enjoyed the inconsistencies of theme and aesthetics, yet were surprised by certain convergences, most particularly by the open, exploratory approach characteristic of all the work. Each woman sites her practice in an 'in-between' sort of space, drawing upon a subjective vision which questions dichotomies and acknowledges complexities. The artists address borders: between land and sea; between light and dark, inside and outside, absence and presence, space and enclosure, image and words; between past, present and future.

I had the opportunity to interview all the artists about the processes and practices through which they make work; this interview material is the basis of the final essay. Here, my interest was in research and development processes, but discussions with the artists indicated the extent to which the biographical was marked within their approach, variously noting problems of the precarious balance between letting a project 'take off' yet supporting it through research. The influence of pictorialism and the extent to which not only what we see but *how* we see is culturally constructed is also a common concern. This awareness is reflected in the attitudes and strategies adopted by the artists in developing their work. A sense of exploration and a desire for fluidity characterize their approaches. As Liz Nicol remarked, 'I think through doing!' – not, 'I think therefore I am!'

In 1972 John Berger observed that 'the relationship between what we see and what we know is never settled.'[2] This draws attention to the tensions inherent in observation, both in terms of seeing and of the ways in which conformity

to the rules of seeing offers us a sense of security, however falsely earned and transient. This is acknowledged through the exploratory approach adopted by the contributors, as artists or as writers.[3] All investigate historical presences within the contemporary, explore resonances between subjective and objective, and question in-between seeing and knowing.

ENDNOTES

1 Woolf, Virgina, *The Waves* (London: Hogarth Press, 1931).

2 Berger, John, *Ways of Seeing* (Harmondsworth: Penguin, 1972) p 7.

3 Indeed, in relation to the latter, I was interested to note ways in which changing titles reflected the exploration process. For instance, I asked John Stathatos to write on women and landscape in other parts of Europe; the first draft arrived under the title 'an absence in the landscape', but later, as he drew together his research information and made sense of it, the title changed to 'a conditional presence'. Similarly, Roberta McGrath, invited to write on women looking, at first suggested the title 'on not being able to see the wood for the trees', but arrived at conclusions better indicated by her revised title, 'on seeing the wood and the trees'.

ÅSA ANDERSSON

WRITING WATER IN ITS ABSENCE

Within remote and unlikely locations I outline *Writing Water in its Absence* ...

The act of sea-mapping happens somewhere between the writing of waves and gestures signifying longing. Desiccated marks tell of an invented movement, of an imagined seepage at a fluid boundary. A tactile make-believe journey in folds and vessels ... powdered.

An intimate space is created by the ambivalence of proximity and distance which forces the gaze to wander both over and through the surface ... Held in transparency, the two photographed and layered realities evoke an elemental yet fictive realm. A small close-up environment, simultaneously outdoor world and inner, imaginary place.

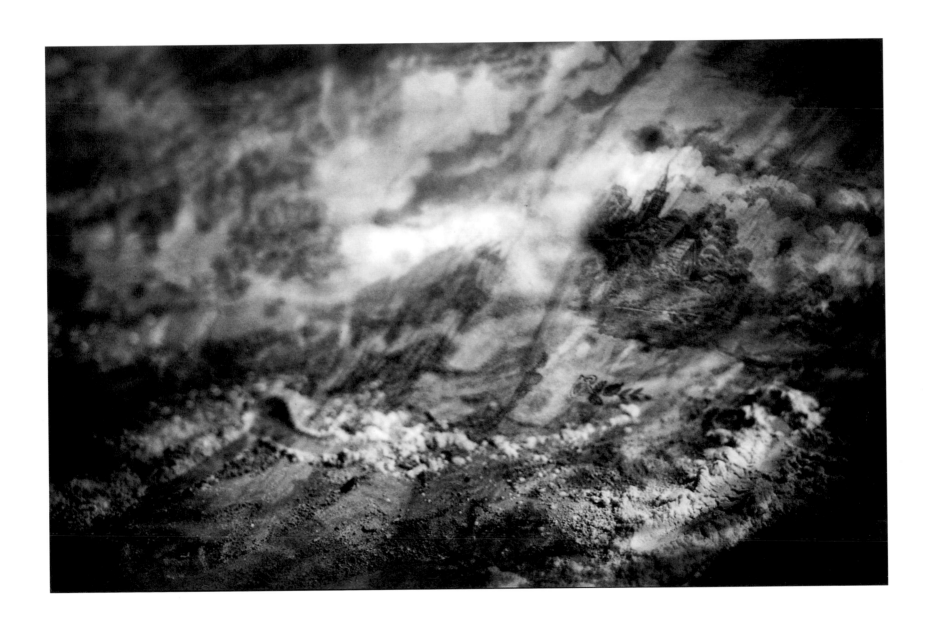

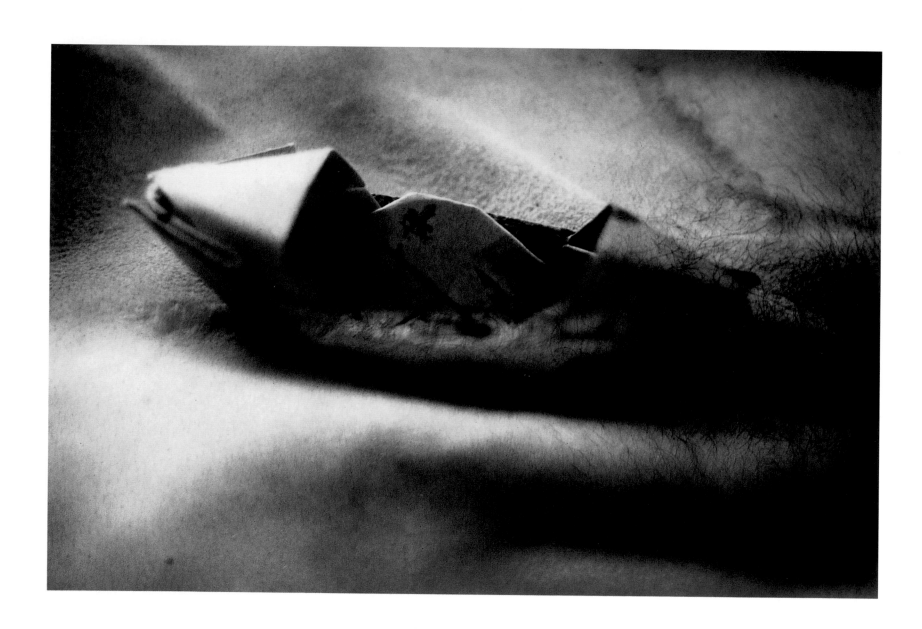

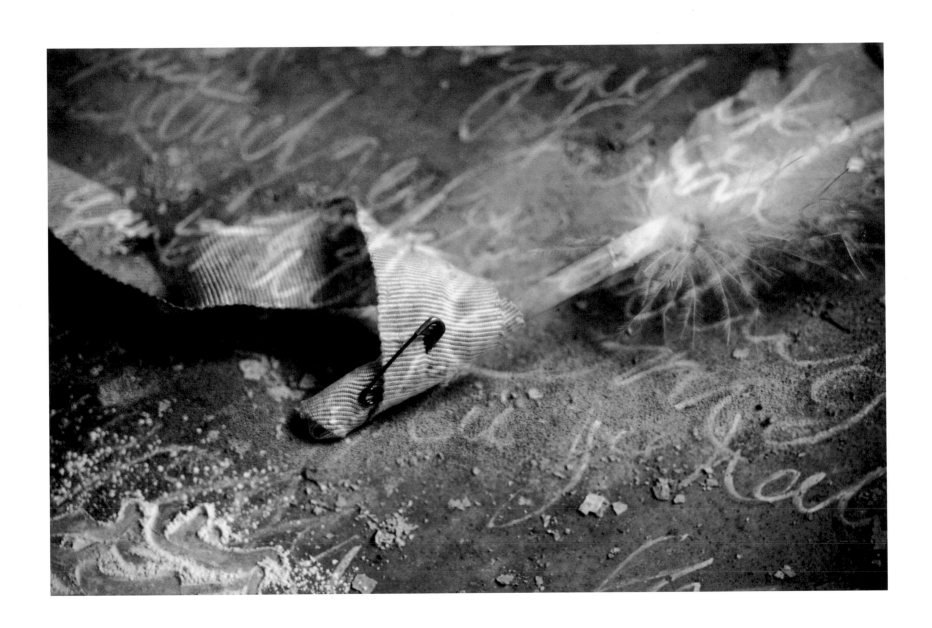

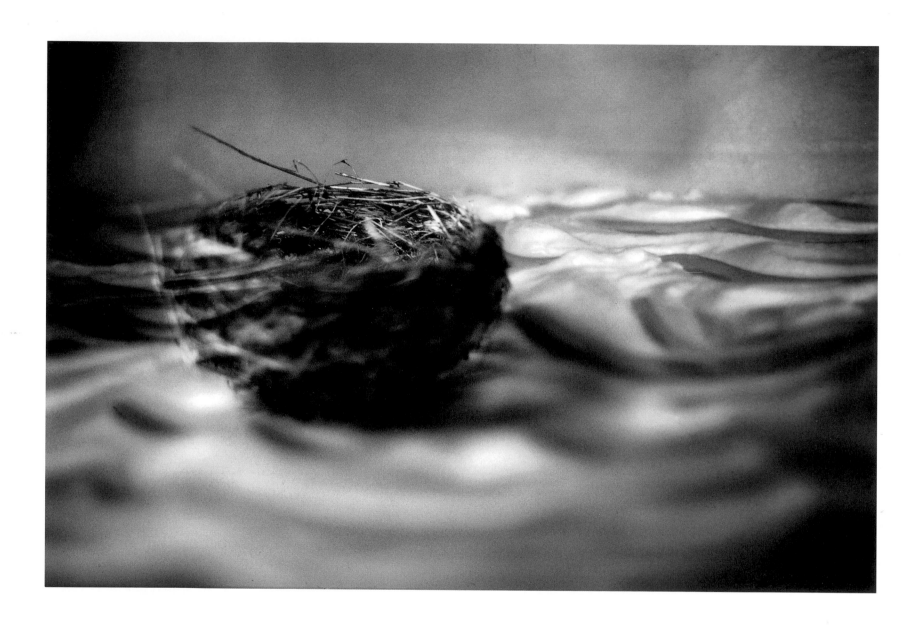

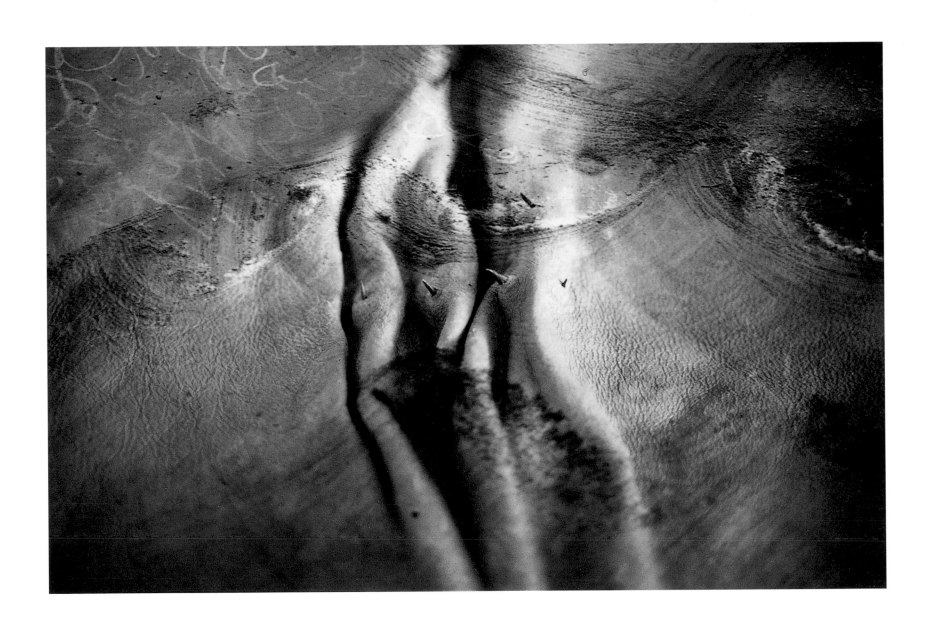

JULIA PECK

FACE

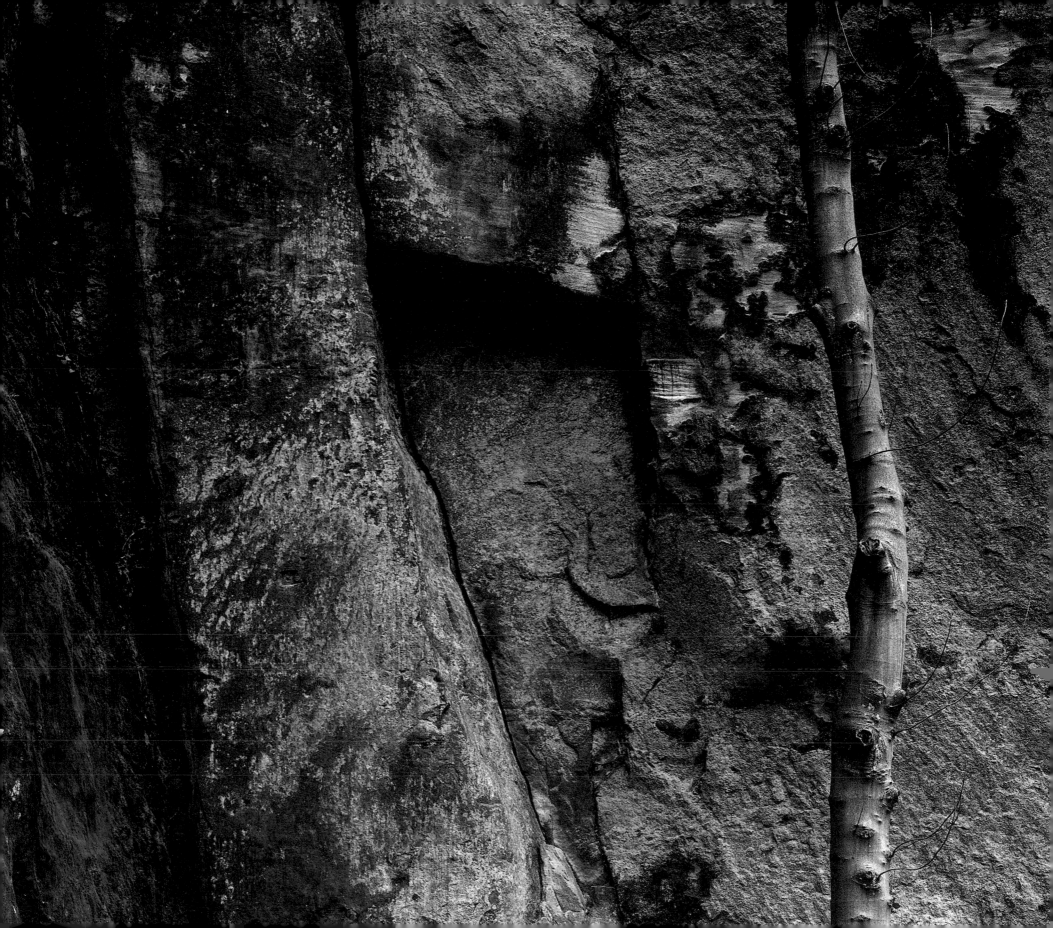

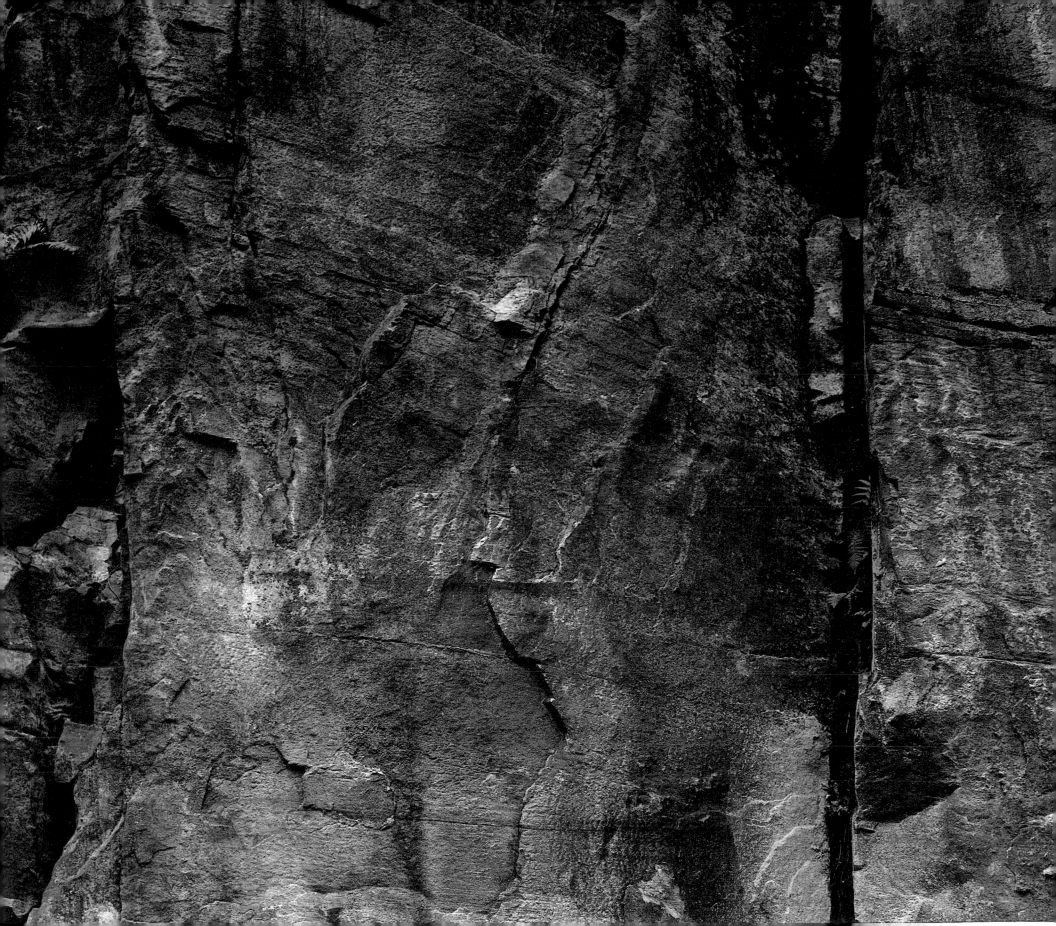

LOU SPENCE

The Present Can Never Be Whole

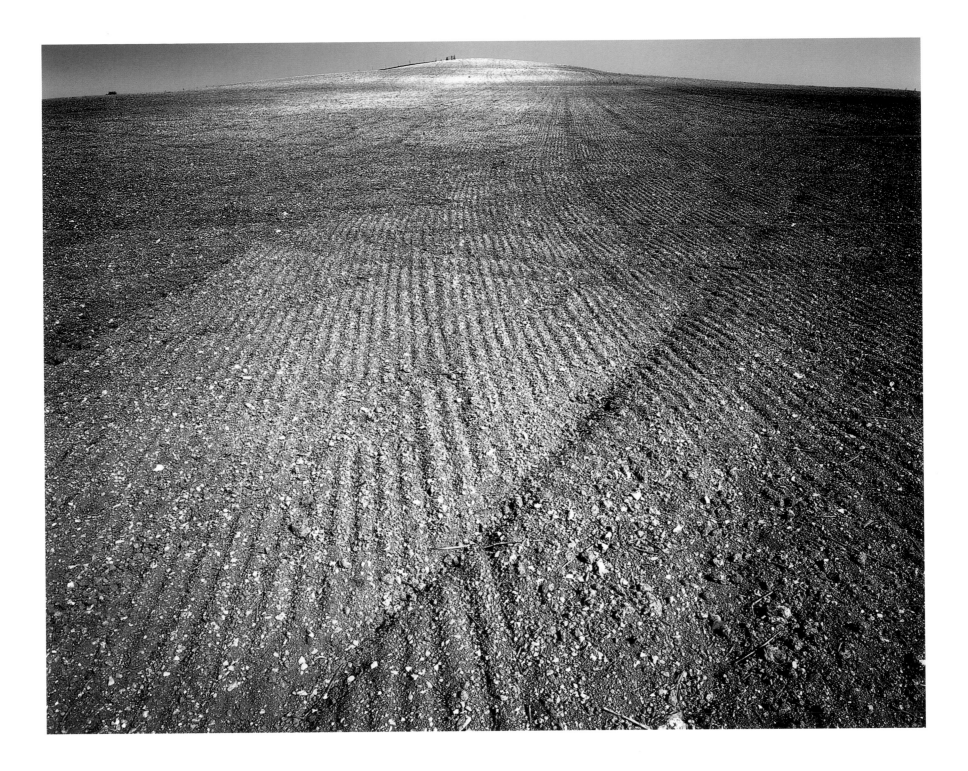

MADDLE FARM — WINTER 1997-8

Identity only becomes an issue when something assumed to be fixed, coherent and stable is displaced by an experience of doubt and uncertainty. This series of images was made in response to a crisis of identity being experienced by those associated with the British agricultural landscape. The photographs portray the area where I was born and brought up and where my parents still farm; it seems that they will be the last generation to do so.

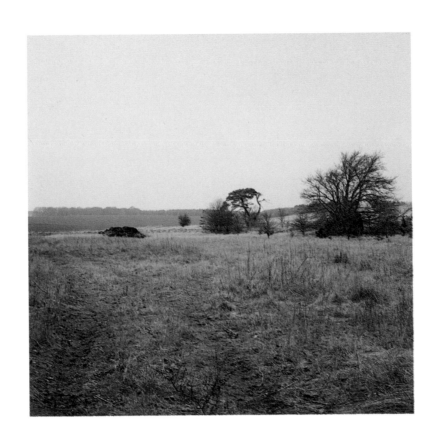

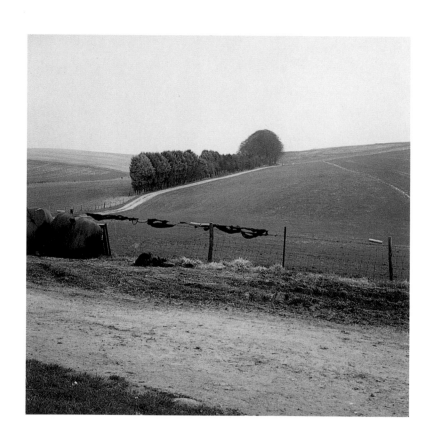 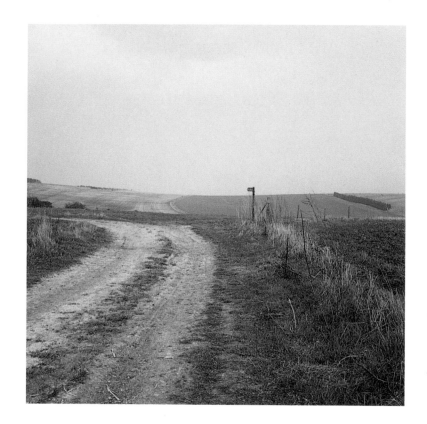

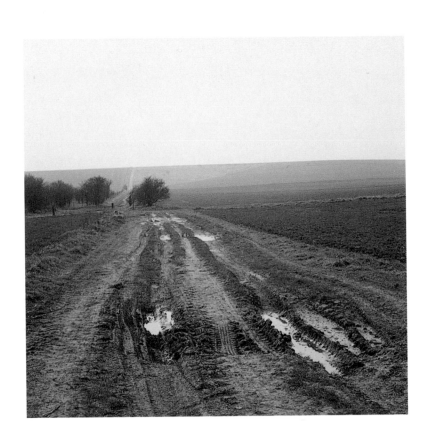 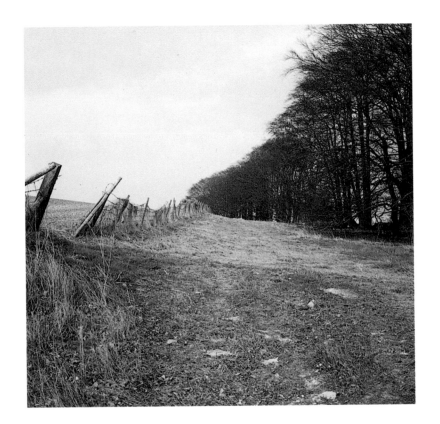

ON BEING ABLE TO SEE THE WOOD AND THE TREES

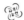

Roberta McGrath

LOCATION, LOCATION, LOCATION: LOOK NOW

*How might we visit in turn all, or most, of the positions one takes to constitute the field ... covering descriptively as much of the terrain as possible,
exploring it on foot rather than looking down at it from an airplane.* J.P. MATHY[1]

This might well describe the experience of looking at the portfolios of images shown here. But it might also tell us something about the nature of looking now. Within recent theoretical debates questions of the subject's participation, cultural location and perspective in constructing any 'field' or 'terrain' have become increasingly important. Vision here is understood as subjective, embodied and situated: all perspectives are partial.[2] What we see depends on not just where we stand but how we then position ourselves within any given field. And this is a political question; not all perspectives are equal.

In place of elevation and speed what is proposed is knowledge that is firmly grounded: embodied and embedded. This is not a god's eye view – or for that matter a goddess's, which is after all the same thing. Mathy hints that what we see from 'up there' is not expansive, but limited. An airplane might be a metaphor for technologies of remote control which dominate our modern visual culture, epitomized by military reconnaissance. Such knowledge is not rooted. From this high-flying perspective the ground beneath is insignificant: details disappear; people do not even register. Without depth, everything appears as a pattern to be passed over on our way to somewhere else.

But perhaps the relationship between human subjects and their objects of study is not as clear cut, which is to say, not as separate, as we thought, or have been taught. Once we stop looking down, distancing ourselves, things look altogether different. We are then on another terrain, not one which privileges the rational mind over physical matter. The hierarchical 'up here' of Cartesian thought, with its other, inferior 'down there', a dark continent of brute matter, only makes sense from the elevated perspective of Enlightened thought. It is not the only way of looking at the world. Being down here means having to face up to, rather than avoid; it means intimacy, being close rather than distant, removed.

Exploring on foot, being a pedestrian, is a metaphor for having to engage with the objects, things and people that get in the way, our way, that divert us; that force us to stop in our tracks rather than press on regardless. Moving through is a very different experience from passing over. For one thing, it means that such a journey is slow and sentimental, not a trip that will get us anywhere fast. We then start to come up against all kinds of things which dramatically change not just what we see, but how we understand a particular field.

Such a journey is hard to imagine before we set out. So habitual are our patterns of thought, so narrow our field of vision, so limited our horizons, that it has become hard to see anything either before or beyond what we have already learned how to see. It is no easy task to imagine different fields, other routes, even less to imagine that we might make our way by another path. And within our own particular fields, so set are we in our desires to get to where we want to go (as what we already know) that we opt to travel along well-worn routes, rather than the myriad of roads that are less travelled. In short, we prefer the comfort of clear signposts and estimated times of arrival at pre-given destinations. We want to know where we are going, when the plain and more painful truth is that we do not.

What is proposed, then, is a reconfiguration of subjects and objects: the possibility of exploration, not as exploitation by a subject who is of necessity on the move, but not on the make. This subject is interested in a politics of location and a world of difference. Any understanding that might be gained on such a journey is not innocent or pure: but partial and of this world. The view from down here is not widescreen but anatomic.

SHIFTING HORIZONS: FIRST STEPS

As a way of thinking about the ideas outlined above and the

images in this book, I want to look at a picture that comes from a different register (Figure 1). This is not a pure image, nor is it a photograph, but an image drawn from the dawn of post-war advertising. It is also, although not incidentally, the stuff of fairy tales. It is a picture from a late-fifties childhood, which remains so fixed in my memory that I am able to recall its every detail some forty years later. I want to use it as a metaphorical walk in the woods, a kind of feminist exploration of landscape which covers, at least, some of the terrain. I want to argue that it might just be possible to see the wood *and* the trees.

In the centre of the foreground, placed closest to the viewer, two small figures are setting off, starting out on a journey. It's easy to step into their shoes and straight away we are on a road to somewhere. We are dwarfed by thick forests on either side. These are forests that are not entirely natural. A straight road has been cut through. The image has a certain, but not total, symmetry. It is a thoroughly modern image. This could be anywhere. It is not a view from above or beyond, but from below. This is where we all start out; we begin by looking up, not down. An open road stretches ahead and it seemed to me, as a child, that with these new shoes on, I could escape, walk right out of my own already restricted life into the picture frame, and just keep on going. The position of the figures and the depth of field encouraged my fantasy. I have everything I need. There is not a parent in sight, but neither am I alone. I have a kind of twin. These children, possibly, but not definitely a boy and girl, walk hand in hand, go at the same pace. I'm not being pulled along by an adult who already knows the way. This is real companionship, real friendship, a relationship that is on an equal footing. We'll help each other: find our own way. It is hardly surprising that I couldn't wait to get those shoes on and start walking. What more could a small girl have wished for?

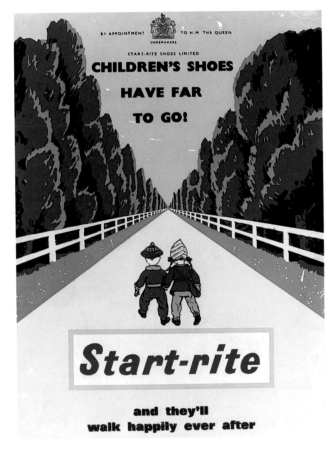

FIGURE 1

This image seemed, and still does seem to me, an image of hope. We have purpose. We don't know where we are going, but stride out confidently anyway. Surrounded by a forest so dense that we literally can't see the wood for the trees, we face an unknown and unexplored future. I wonder about what lies beyond the vanishing point. We don't know what we will find and this seems exciting, not a source of anxiety. These are not children lost in the wood, but children who will find their own way. We are not alone: what we would see and where we would go next would be shaped no doubt, by some discussion. What would we find? Where would we go? Would we go on together, or go our separate ways? Perhaps the way wouldn't always be so clearly marked, maybe not even marked at all. What would we do? The fact that the figures had satchels over their shoulders seemed to me, in fantasy at any rate, to mean that we were not going home. And of course, the little figures do not walk towards the viewer. We have already turned our backs, packed our bags; the past is behind us; we are already on our way to a new future: there's no stopping us and we don't, we won't, look back.

This image is a kind of visual analogy for the idea that from the very moment we are born we have lost our origin.[3] We are on a one-way journey. There's no going back and the two little figures seem to epitomize this brutal fact of life. This is, however, also a journey of adventure; of new horizons and different places. It offers the possibility, the hope, of independence which as small children we must feel, and must exert at the very least in fantasy, in order to be 'ourselves'. (Around the age of three, children usually tell their parents that they can now be dispensed with; that their services are no longer required.) The picture is not the tidy, claustrophobic, domestic interiors which haunt children's lives; this is the great outdoors, life on the open road, fresh air, a first taste of what freedom might be like. It is an image

of transition which stands between what we once were (small dependent children) and what we hope to become (autonomous adults).

Dependence and autonomy are however not mutually exclusive but intricately entwined. Unlike the advertising image, with the way ahead clear, obstacles increasingly get in the way. Journeys that start right, begin so well, with a future before us, inevitably, necessarily become much more complex and difficult. The children have escaped but not yet arrived. Caught, but not trapped, in a transition between two places: one known, one unknown; their life is not yet mapped out and, importantly, it has not been mapped out for them. There is, of course, always a past, and this shapes, but doesn't necessarily determine, our future. The function of a transitional space is not simply to get us from A to B. It is not the getting there that matters (we all get there in the end), but how we get there, the process through which we get there. If we press on the image a little further we might use it to explore the nature of transitional spaces as places between reality and fantasy; places which resist dichotomization and propose radically other, different ways of ordering our experience. Indeed one of the pleasures of much of the work in this book is that it offers spaces in which we can lose ourselves. These are dreamy images – we can become lost in reverie.

Transitional spaces are places between, and a transitional object is a kind of half-way house between subjective and objective where the perception of an object clearly differentiated from the subject has not been reached. The transitional object mediates between a purely internal private subjective world and an external objective reality. In infant development the crucial aspect is that this is a 'neutral area of experience which will not be challenged'.[4] The question of coming from within or without, of belonging to internal or external reality does not arise. According to Winnicott this world which belongs to neither, is a third space, a potential space, a cultural space where the child becomes lost in play. More importantly, this space is not confined to infancy or early childhood, but is 'retained throughout life in the intense experiencing that belongs to the arts and to religion and to imaginative living, and to creative scientific work'.[5] We make and look at, linger, in places and pictures in order to re-kindle that intense experience. Moreover, photographs are themselves rather like transitional objects; historically situated between painting and film, they function as particularly powerful intermediaries between an intensely internal subjective world and a shared external reality.

This might also suggest that the boundaries between internal and external reality, between subjects and objects, unconscious and conscious, feeling and thinking, are much less clear than we might believe. Transitional spaces are the bridges between these two worlds. And contrary to popular belief it is perfectly possible, even desirable to 'blur boundaries without burning bridges'; to creatively use both external and internal registers of thought and feeling.[6] Culture, visual culture, then, is at best the imaginative use of what already exists and the ability to transform it into something else: a different reality; a creative space as a place where we can change things, rather than simply fitting in, keeping everything fixed in place.

WORDS AND PICTURES

But this is a difficult task. Around this same time children start to acquire language, the material that allows us to express ourselves; 'to be inventive ... but only within already given horizons'.[7] Phillips describes language as 'the cure for infancy ... between two and three years old ... it is as though she has to give up what she can never in fact relinquish – her inarticulate self, the self before language ... a passionate life without words.'[8] Anyone who has ever watched the immense effort, the muscular contortions of a small child speaking, is instantly reminded that language is material. And while we become more physically adept, more fluent, the struggle to articulate meaningfully is a life-long project. More often than not words, and images, fail us. The trouble with words, as Dennis Potter put it bluntly, is that you never know whose mouth they've been in. This is an image of language as promiscuous, penetrating. I might be forced to eat my words, or worse, having tried to swallow other peoples words I might choke on them; I might spit them out or be forced to eat them. In their different ways, Potter and Phillips suggest that what we do, what our projects are, is always 'formed by a series of designs from those who are supposed to know' (and should know better) and these stories are crucial to the people we later become. As in the transitional space, the question of whether words, or images, come from within or without makes no sense: it is the stuff from and through which we fashion our own identities and projects. This might help to explain why it is so hard to see things differently and to imagine other configurations.

We could say that like the twins' (as the Start-rite advertisers called them), the paths we take are determined by the guardians who make up and choose the stories the children will be told.[9] We might think of these as good enough stories. Stories, as Phillips suggests, that we can do something with, make something of. The point is, of course, that they don't need to be perfect, just better. And the problem is that we very often feel that our horizons are limited. Instead of new horizons opening up as we go on, possibilities seem all too often to close down. Our stories, developed from the explanations or understandings that we

are given, often become inadequate: they are not good enough. What matters here is the struggle to articulate, to say something different, something else. This is no easy task, but then again it is the only task worth doing. And it is a task which feminism, as a necessarily contaminated, imperfect project, has set itself.

A JOURNEY OF HOPE

In his book *Towards 2000*, Raymond Williams tells us stories that might help us on our way, give us hope, enable us to go forward. Hope is of course about possibility and Williams spent his life writing about the importance of cultural politics and so became a kind of 'good' father figure for cultural and visual cultural studies. Williams was interested in narratives, stories that were more adequate to the complexities of the present, and the power of Williams' writing lies in its clarity; its straightforwardness. In his final chapter 'Resources for a Journey of Hope', Williams ends with a phrase that is both complex and simple, but above all wonderfully hopeful: 'if there are no easy answers,' he says, ' there are still available and discoverable hard answers, and it is these that we can now learn to make and share.'[10] And this is not unlike Braidotti's

claim that '... living in transition does not mean that one cannot or is unwilling to create those necessarily stable and reassuring bases for identity that allow one to function as a community.'[11] Answers, representations, identities, have to be made by subjects, by us, fashioned, out of something; they have to be created, and more importantly, shared. This is an ordinary, practical, material and political activity. Like the Start-rite twins, Williams and Braidotti are an odd theoretical couple, but both accounts, from their very different perspectives, place a high value on political subjectivity, on agency; and both hold out the possibility, the hope, of a collective cultural politics that will make a difference.

Feminist epistemology as a transitional knowledge has simultaneously resisted and acknowledged what divides us: differences, as much as shared interests. It does not aim to eradicate those differences, nor simply to tolerate them or understand them, but to make a reconfigured sense of them. In the spirit of hope, in an age of accelerated transition, of shifting identities and horizons, we need to make and share answers that can keep what seems incompatible alive. This is what good enough, imaginative theories and images do. And while imagination with its close association with images, is generally seen as something childish, it should not be

underestimated. Imagination is about the magical power to transform; to conjure up; to evoke; to provide places through and in which we can begin to think not only about ourselves, but about the material and conceptual worlds that we must inhabit. There is far to go.

ENDNOTES

1 Quoted in Pile, Steve and Thrift, Nigel, *Mapping the Subject* (London: Routledge, 1995) p 1.
2 Haraway, Donna, 'A Manifesto for Cyborgs', *Socialist Review* 80, 1985.
3 Braidotti, Rosi, *Nomadic Subjects* (New York: Columbia University Press, 1994) p 14.
4 Laplanche, Jean and Pontalis, J.B., *The Language of Psychoanalysis* (London: Hogarth Press, 1973) p 464.
5 Laplanche and Pontalis, J.B., *The Language of Psychoanalysis* pp 464-5.
6 Braidotti, *Nomadic Subjects* p 4.
7 Phillips, Adam, *The Beast in the Nursery* (London: Faber and Faber, 1998) p 44.
8 Phillips, *The Beast in the Nursery* pp 39-40.
9 Phillips, *The Beast in the Nursery* p 116.
10 Williams, Raymond, *Towards 2000* (London: Pelican, 1983) pp 268-9.
11 Braidotti, *Nomadic Subjects* p 33.

NOTES ON BEAUTY AND LANDSCAPE[1]

David Bate

'Beauty', a notion associated with conservative aesthetics is a topic often treated with scorn. But the more I think about it, the more important something like beauty is in contemporary issues of landscape, about 'rural myths', property, ideas of nature and the natural, 'mother nature', national and ethnic identity and what we use landscape images for. In fact beauty is something that will not go away from any of those issues until it is dealt with (properly). The common notion of beauty is of something which gives delight, satisfaction or pleasure. It is this conventional definition of beauty, as having something to do with feelings about an object, a place or space, as providing a pleasure, which cannot be ignored. Pleasure has been seen to be an issue in representation for some time as a question of what pleasure is given and why, to whom and what for?

Obviously the question of beauty extends way beyond photography and any particular genre. I am concerned here, then, with beauty within a particular representational field: landscape. I want to sketch here, briefly, something of a context for the way that beauty has been related to pictures of the land. With the invention of photography in the nineteenth century, photographers interested in art took their values from and 'cannibalized' the genres and values of paintings in the existing Art Academies. In nineteenth-century England, the highest of the academic genres was not history painting, as in France, but landscape painting. This had to do with the particular, if not peculiar, relation to the concept of the picturesque in England and English culture.

HISTORY

The picturesque, a word of Italian origin meaning 'the point of view essentially of a painter' was elaborated as a theory in England between 1730-1830.[2] It is a theory whose practice took the form of poetry (Thompson and Dyer) derived from the pictorial forms of painting. This interest in the Italian picturesque was imported by wealthy English visitors who travelled to Italy as part of their 'Grand Tour' and brought back – and filled their homes with – Italian picturesque paintings. It was from those paintings that garden designers like Capability Brown began to shape the gardens of country homes in the fashion of the pictures. Thus in the history of landscape gardening, the picture is the referent for the gardener, not the other way around. 'Nature' was shaped according to pictures of how it should look.

The seventeenth-century paintings of Claude Lorrain can stand here as emblematic of the type of image which this eighteenth-century English picturesque drew upon. This is in contrast with the other type of landscape picture, the 'sublime', found in paintings by Salvator Rosa. The English painters whose work can be seen to fall into such categories are Constable for the picturesque and Turner for the sublime, though this is only a rough, general and simplified distinction. This eighteenth-century distinction between the picturesque and the sublime was certainly important. Today the terms are still important in that they remain latent in contemporary discussions on beauty in art and landscape photography.

However, even though the eighteenth-century period is attributed as the common origin of the picturesque, it is worth noting that there is both genre painting and pastoral poetry to be found in the ancient Greek Hellenistic period. The eighteenth-century picturesque is therefore already an emulation of an earlier Greek picturesque and arcadia. The longevity of this form, its historical repetitions and renewals should indicate to us that it has a significant function in relation to fundamental processes of human thought. Indeed, I want to argue that 'landscape' is the taking shape in symbolic form of a space for the projection of psychical thoughts on culture, identification and 'civilization' under the name of 'Nature' more than it is a treatise on any putative 'nature' or land itself.

BEAUTY AND THE SUBLIME

In the mid-eighteenth century it is Edmund Burke in his 1757 book *Enquiry into the Origin of our Ideas of the Sublime and Beautiful* who tries to theorize the aesthetic – emotional – effect of beauty.[3] Burke is credited, as the title of his book indicates, with making a distinction between two categories: 'the beautiful' in the form of the picturesque, and the sublime. Other writers followed and developed a particular fashion for the picturesque, for example, the Reverend William Gilpin and Richard Payne Knight, two men who wrote books, sparsely illustrated with rough sketches, advocating various parts of the country as 'picturesque'.

These travellers' writings served as guide books for the more competent picture makers who subsequently rendered these pre-viewed sites into the appropriate pictorial visual style and coding.

A typical example of a picturesque scene was 'a hovel' beneath a gnarled oak tree with 'an aged gypsy, a rusty donkey, mellow tints, dark shadows', or an expansive autumnal landscape with an old farmer or parson with his daughter. Alpine-type landscapes were particularly popular, hence the rush to North Wales and the Lake District by writers and painters in the 1760s.[4] Those familiar with the history of photography will recall that almost exactly a hundred years later, in the 1860s there was a similar rush to the Lake District with the same enthusiasm for the picturesque by Roger Fenton, Francis Frith and the many others who trod in their path. The making of picturesque landscape views in the area, with industrialization, the increasing democracy of travel and 'leisure', produced a whole industry which mapped the routes of picturesque travel for the 'masses'. An industry whose success in encouraging the 'masses' to these places in turn, was precisely the thing which threatened to ruin these picturesque views.

What such views gave, of course, were idealized views of the countryside as nature and, indeed, as natural. This sort of picturesque view with its quite conventional sense of beauty is nothing other than a view which has already been given, already been seen. It is still ever present today in advertising images (especially health, holiday and car advertising images), picture postcards, tourist and heritage industries and the history of art, to mention only the most obvious. The tourist who visits a picturesque spot is the consumer of a pre-constituted view, one which is still given today under the name of the 'beauty spot'. It is an 'easy' pleasure. We go to a beauty spot on 'a day off' to stand where the view can be 'appreciated' and inhaled. The beauty spot is just the place where everything has already been arranged for you to feel and appreciate the beauty, 'this is where to stand to see it', a view that is already represented from the same given point of view in the postcard. In other words, the position offered by picturesque beauty is of a conservative acceptance of the existing scene, its forms and structures, a 'this is where I fit.'

In contrast to this set of characteristics, the sublime is something more akin to what the Highway Code designates as a 'black spot', a representation which is a 'warning sign'. Unlike the beauty spot, the black spot is a place which is threatening, a place to be fearful which is given an aura of danger.[5] Salvator Rosa's paintings, for example, have threatening, half broken, overhanging trees and rocks – invoking 'nature' as something which is far from calm and with the potential of a totally destructive force.[6] The National Gallery in London has a painting by Salvator Rosa of 'Witches at their Incantations', a scene in which it is the nature of the human figures that is wild and certainly threatening. Turner's sublime is mostly (that is, not in *all* of the paintings) represented with scenes of the sea, not a calm and tranquil 'picturesque ' scene, but nature in all its fury and force. It is stormy and threatening, but for the small figures depicted in the tiny boats on it, almost completely overwhelming.[7] The sublime, then, is something which threatens to overwhelm you and which causes fear, but as a spectator the threat is at a level that can be tolerated. It is about the capacity to experience being fearful, but not being absolutely overwhelmed, of still being able to tolerate and contain it. This is clearly articulated in Burke:

Whatever is fitted in any sort to excite the ideas of pain, and danger, that is to say, whatever is in any sort terrible, or is conversant about terrible objects, or operates in a manner analogous to terror, is a source of the sublime; that is, it is productive of the strongest emotion which the mind is capable of feeling.[8]

It is perhaps easier to think about this in its more common modern forms, one of which of course is the 'horror' genre. Those novels, films, photographs and so on, test the capacity of the viewing subject to tolerate more and more the scenes which, if readers participate in them, represent a threat to them. Clearly the relationship to pleasure and beauty in these texts is complex and, although this is not something that there is space to argue here, the industries that produce horror could certainly not be sustained if there was not some form of pleasure in it derived by the spectators who pay for the pleasure of such experiences.

COMPOSURE

These two modes, the picturesque and the sublime, or beauty spot and black spot, need to be related back to the issue of beauty and landscape photography. In his 1934 lecture in Paris (delivered at the Institute for the study of Fascism), 'The Author as Producer', Walter Benjamin says in a famous remark about the development of photography in the 1930s:

It has become more and more modern, and the result is that it is now incapable of photographing a tenement or a rubbish-heap without transfiguring it. Not to mention a river or an electric cable factory: in front of these, photography can now only say, 'How beautiful.'[9]

Of course to make an ugly or 'unpleasant' object into something beautiful, at one level, only demonstrates the skill

of the producer to subdue the ugliness into the appearance of something beautiful in the picture.[10] But the issue of beautification needs to be looked at in a different way if we are to see the politics of beauty in relation to landscape.

Concerned and oppositional photographic practices have attempted to undo this reduction of the world to the category of the beautiful in image practices. From whatever starting position, such 'de-mythologizing' practices have had the shared project of throwing off the shroud of beauty, of showing how the idealization of subject matters represses, ignores or 'mis-represents' real social relations. In other words they have tried to demonstrate how the experience of a picture as beautiful, or let's say pleasurable, can lead to a so-called 'false consciousness' or wrong-headedness about how the world really is. But there has always been a resistance to this sort of criticism. There is something about picturesque images which cannot be waved away or dispelled – their pleasure. No matter how much rational critique is made, individuals tenaciously cling to the pleasure of this or that image, no matter how far others find the same image to be appallingly 'cliché', trite or meaningless. There is, I suggest, a fascination with something about the image as beautiful which persists in spite of any conscious knowledge about the material social or political status of landscapes as 'rural myth', romanticism and so on. It appears as though the spectator is in the grip of some emotional effect of pleasure which no amount of 'deconstruction' or rational criticism will release or stop.

One way to understand this grip of pleasure is through the composition of the picture in relation to the spectator. The beauty of objects in representational forms is commonly regarded as having something to do with proportion and symmetry. When a spectator's eye drifts off out of the frame they are no longer looking at the picture. Good composition, it is said, as any photography handbook will have as an unwritten rule, is about keeping the eye of the spectator within the frame.[11] So long as the spectator's eye is within the frame they are looking at the picture. To do this, the scene must 'harmonize the parts to the whole'. In the picturesque (for example, a Constable painting), a conventional 'good composition' is one that enables the spectator also to recognize the scene as a scene – it is what makes the whole structure work. This pleasure in 'recognition' should not be underestimated. The beauty spot is similarly the spot to stand on for the viewer to have an (imaginary) command of the scene. In the activity of seeing, 'the drive to master' is one of the key components of looking. The picturesque is a form in which everything is supposed to be 'in its right place', organized, precisely 'composed' and controlled. The poor peasant is pictured by their hovel, or the agrarian worker is seen working in their master's field and so on. They are all 'in the right place'. Here content and form become one through 'harmony' and 'balance'. A 'good composition' in relation to the pictorial form of the picturesque gives a certain type of satisfaction and pleasure for the viewer which results in the spectator having an experience of the beautiful. 'Good composition' satisfies the composure of the viewing subject.[12]

In Freudian psychoanalysis it is the ego which constantly attempts to organize the human subject, it keeps the mass of drives functioning as a coherent (if imaginary) 'person'. The ego is the 'seat of composure', it is as an agency of control. Composure of a person then, the subduing of various parts to a whole, is just like composition in a picture; it is a way of organizing and containing excitement, since adult life is mostly about containing, binding sexual excitement into sublimated forms. The pleasure derived from the composition of picturesque beauty is a pleasure in the recognition of order, precisely what the ego wants: a unity and organization of the (imaginary) coherent 'self'. It is as if someone says to themselves, 'this order and harmony that I see in the picture is the order and harmony that I wish in myself.' The organization of the picture is identified with a corresponding internalized sense of satisfaction of the ego in the human subject: 'I have finally organized everything into a unity, it is all in the right place.' If this structural relation between the composure of the human subject and the composition of the pictorial object sounds preposterous, just think of the way that when someone *loses* a love object, a 'person' or thing, their composure and self-value can crumble or be damaged. Someone can quite literally 'go to pieces' at the loss of a loved thing, thus *losing* their composure. What is externally lost is reciprocated internally as the lost property of the ego. Conversely, a badly composed picture may well invoke a sense of distress, but for the reason that it fails to provide a seat for composure. Or alternatively, someone who suddenly cries when they see a picturesque scene may well be, unconsciously, recognizing their own lack of composure. Such remarks obviously require further scrutiny. However, the picturesque is certainly a form which *invites* composure through a narcissistic identification with, and mastery of, the organized scene. The picturesque offers an image for potential 'fullness'. So when someone says 'this picture is for me' or it is 'just my sort of picture', they are recognizing themselves in, as belonging to, identifying with, the organization of the scene. These sorts of argument are already intuited in the way that picturesque beauty is so despised and maligned by critics. In contrast with the sublime, it is hard to find contemporary cultural critics advocating the picturesque as a radical or interesting form. Discussion of the picturesque is mostly in negative terms, but this underestimates the extent to which it can be valued positively, as something that gets you through a situation,

something that enlists you into a composure, but one which may nevertheless be complacent.

In fact, the issue of the politics of this pleasure becomes much clearer and acute when considered in relation to particular issues, for example, when landscape is invoked by discourses of nationalist fervour, male sexual or class anxiety (expressed as a fear of social disorder), or in struggles of property rights, ecology and during wars. So when 'the land' is invoked as something to be protected as the 'blood and soil' of a nation or specified 'race' (rather than of the entire community of different ethnic groups, etc) as has so often been the case in the historical uses of landscape imagery, the idea of 'composure' (a narcissistic unity to the exclusion of others) becomes a real problem; it elicits, invites, a violent process of cleansing the 'contaminating' elements, that is, the unwelcome debris of people's 'rubbish', from the otherwise 'pure' scene. It is precisely in the idea which says that someone or something 'does not fit in the picture', that the composure of an 'us' is constituted at the same time as an 'ideal' picture is construed by the exclusion of a 'them' or 'that'. Or, in the so-called cultural identity 'crisis' of who 'we' are or what 'we' identify with, a picturesque landscape responds reassuringly that 'this picture represents what we believed had been lost, whatever that is, Englishness perhaps, which this image also makes present again here and now.' This is why landscape is so often associated with a contemplative mood akin to melancholia, a 'pleasure' or satisfaction derived from longing for something past or lost. Perhaps this is also why the pastoral picturesque scene has, over the centuries, offered itself as a kind of solution to the discontents of civilization.[13] Discontent is invested in a 'return to nature', a hope, with 'Nature' as the name given to what is really an appeal to a narcissistic pleasure of completeness (psychoanalysis might say an appeal to the lost mother that every infant had) in the

face of an attempt at mastery over a cultural structure which inevitably resists it.

As for the sublime, the relation to composure is clearly one of testing the capacity of the ego to tolerate excitements. This is a different kind of pleasure, one which excites desire rather than one which subdues or disarms it. Whereas beauty in the picturesque form is insensitive to outrage, the sublime revels in it, enjoys and tests capacity for pain. In the writings of Edmund Burke, who was a conservative politically, the category of the beautiful is linked with notions of 'society'. So for Burke the picturesque suggests the harmonizing of individual passions to the whole (society) whereas the sublime is linked with anti- or asocial feelings and invokes passions which he thought isolated individuals in fearful states of self-preservation (consider this in relation to the sublime of recent car advertising images). Edmund Burke's gloss on the sublime makes the rising of the passions seem like a vice not a virtue, that is, as a potential threat to a stabilized society.[14] It must then be obvious why 'avant-garde' art has so often been an aesthetic of the sublime, precisely to invoke the 'unthinkable' about a society. It is notable, for instance, that the work which Walter Benjamin champions in his article (quoted above) is that of John Heartfield whose photomontage work mostly uses a rhetoric of the sublime, anchored to the politics of anti-fascism.

However, I do not want to close, 'essentialize', the categories of picturesque and sublime by polarizing them as respectively bad and good, because the issue of beauty and pleasure derived from these forms has to be related *strategically* to the particular goals and issues of the work — I'm assuming of course, as Benjamin did, that a producer does have a commitment to 'something' in their work. In recent years artists and photographers have been working, consciously or not, both with the sublime and the beautiful

in ways which challenge the assumptions in both. The picturesque has been 'quoted' in order to critique it (parody, irony, allegory) while the sublime has been used in feminist critique, in relation to representations of sexual difference and relations to nature, as well as ecological arguments.

In summary then, the aim of the beautiful (to find an ideal object and form which apprehends it) is something which can never finally be achieved, but the picturesque is one form which tries to find or, rather, *produce* it and subdue it (something which can be loved *as* mastered). The sublime is the form which shows the impossibility of this. The relation of any spectator to these depends on the way that scenes have been coded, the cultural context in which they are seen and the particular disposition of the spectator to those feelings of composure and terror. Yet inevitably, with our 'postmodern' formation, the polarized oppositions which sustain these categories are themselves mutating, just as the classical forms of landscape which dominate its history are themselves exploding into the fragments and shards of our decentred attitude to modernity.

ENDNOTES

1 This text is based on a talk given at the 'Changing Views of the Landscape 2' photography conference held in Ilkley, Yorkshire, 4 September 1998, thanks to Shirley Read for inviting me to speak.

2 Praz, Mario, *The Romantic Agony*, (London: Fontana, 1966) pp 37-40.

3 Burke, Edmund, *A Philosophical Enquiry into the Origin of our Ideas of the Sublime and Beautiful* (London: Routledge and Kegan Paul, 1967). A 're-discovery' of the text *On the Sublime* by the Greek first-century writer Longinus was published in 1674 and provided a key reference for the revival of the sublime in the late seventeenth and early eighteenth centuries.

4 Praz, *The Romantic Agony* p 39.

5 Some may find in this term *'black* spot' a 'racist' connotation. While it would be reductive to read *every* use of 'black' back to an issue of race there is no doubt a history to be developed here on the origin of the term 'black spot'. See Franz Fanon's essay 'The Fact of Blackness' which draws out the consequences of what an encounter with a 'Negro' can be as a kind of terror for both the white and the black. *Black Skins, White Masks,* Fanon, Frantz (London: Pluto, 1986).

6 Salvator Rosa was one of the first painters of the sublime.

7 An exemplary image here is Turner's 'Slave Ship' painting (also known as 'Slavers throwing overboard the Dead and Dying – Typhoon Coming On') Museum of Fine Arts, Boston, which combines the sublime with colonial anxieties. See Paul Gilroy's 'Art of Darkness' in *Third Text* no. 10, 1990.

8 Burke, *A Philosophical Enquiry into the Origin of our Ideas of the Sublime and Beautiful* p 39.

9 Benjamin, Walter, *Understanding Brecht,* translated by Stanley Mitchell (London: New Left Books, 1977) p 94.

10 See Mark Cousin's essay 'The Ugly' in *AA Files* no. 28, Autumn, 1994.

11 See 'Looking at Photographs' in Burgin, Victor, (ed.) *Thinking Photography* (Basingstoke: Macmillan, 1982).

12 See the essay 'On Composure' in Phillips, Adam, *On Kissing, Tickling and Being Bored* (London: Faber & Faber, 1993).

13 A whole separate argument can be developed here around the issue of landscape, beauty and mourning. This is certainly relevant for an understanding of landscape in relation to nationalism as an identification with something that is 'being lost'. The relation of beauty to lost objects is explored by Freud in his 1917 essay 'Mourning and Melancholia' (*On Metapsychology*, Pelican Freud Library Volume 11) and in his short 1916 essay 'On Transience' (*Art and Literature*, Pelican Freud Library Volume 14). See also the short essay by Julia Kristeva, 'Beauty: The Depressive's Other Realm' in Kristeva, Julia, *Black Sun,* (Oxford: Columbia University Press, 1989).

14 See Ferguson, Frances, *Solitude and the Sublime* (London: Routledge, 1992).

GINA GLOVER

Pathways to Memory

If we hope to live not just from moment to moment, but in true consciousness of our existence, then our greatest need and most difficult achievement is to find meaning in our lives.
The Uses of Enchantment BRUNO BETTELHEIM

In her search for meaning and the lost enchantment of childhood, Glover embarks on a photographic quest and invites us to enter her special garden. This garden has become the location for fairy tales. As Bettelheim says, 'without our awareness the unconscious takes us back to the oldest times of our lives and like fairy tales, suggests a voyage into the interior of our mind, into the realms of unawareness and the unconscious.'

Glover travels along connecting pathways, caught in a spiral of associations – she returns to the animistic thinking of the child, where there is no separation between inanimate objects and living things. It is a time when, like the philosophers, children search for the first and last questions of life: 'Who am I? How should I deal with life's problems?' – questions which also arise at stressful times in adult life.

The worn paths and stonework evoke not only a sense of the past, but also of an elusive memory of the many people of all ages who lingered there. Her garden becomes the safe playground for the interpretation of the symbols and impressions which have haunted Glover all her life.

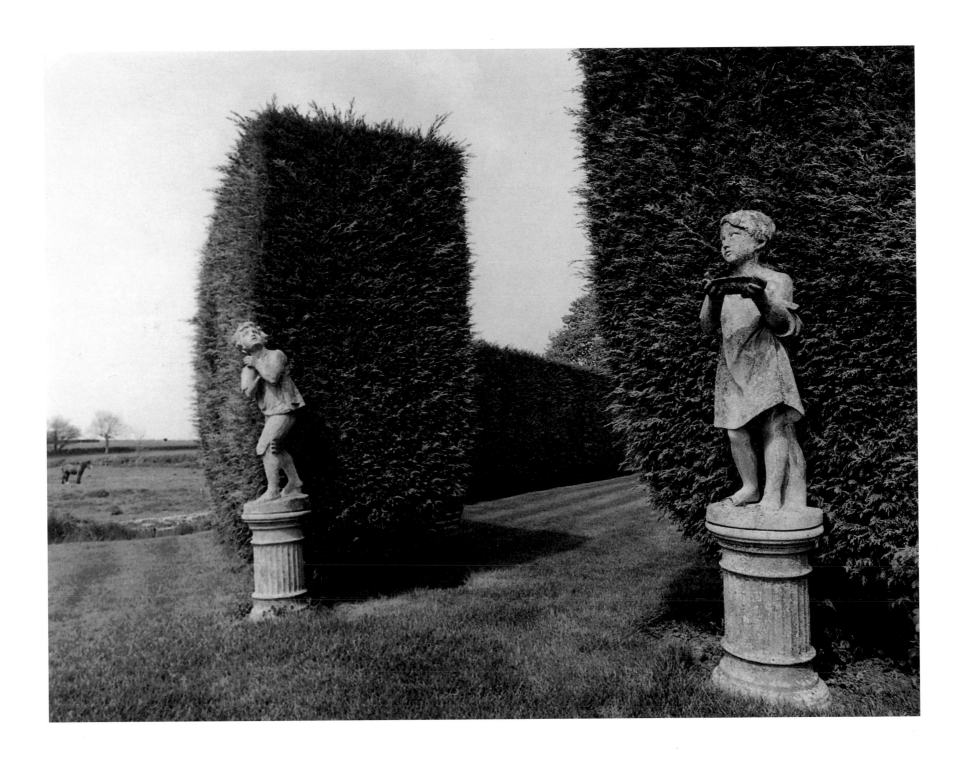

SIAN BONNELL

Undercurrents

The influence and presence of the sea is always with us in the island Britain. Reminders of the course of evolution, as creatures emerged from the sea to inhabit the land can still be seen as the coast erodes. These traces are embedded in our consciousness and link us to a distant past we can still experience through sight and touch. This timeless immediacy contrasts with our own souvenir culture.

GEORGE MEYRICK

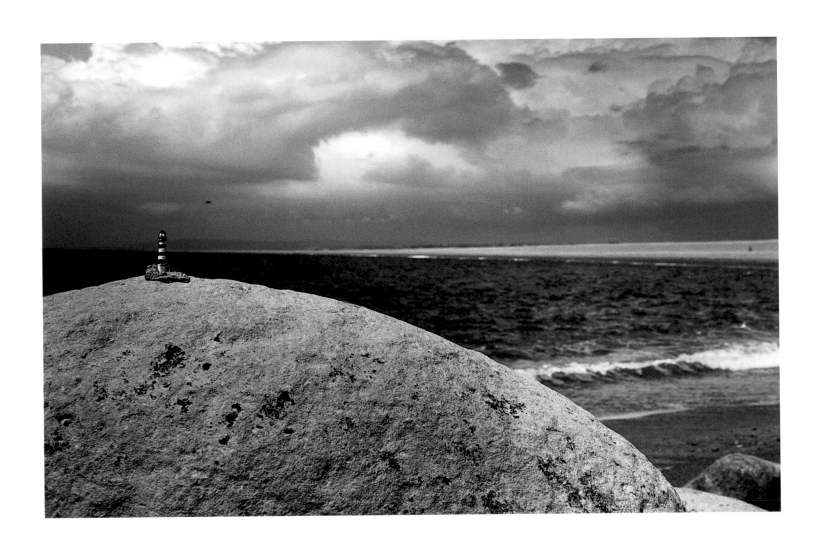

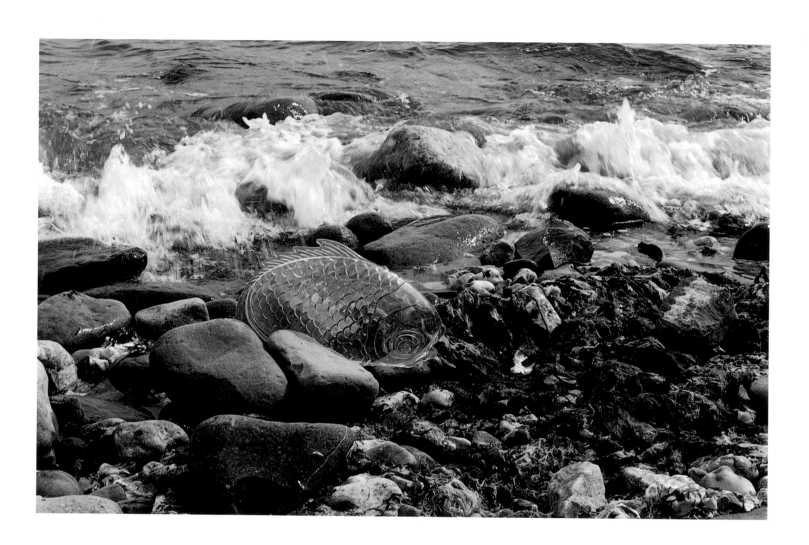

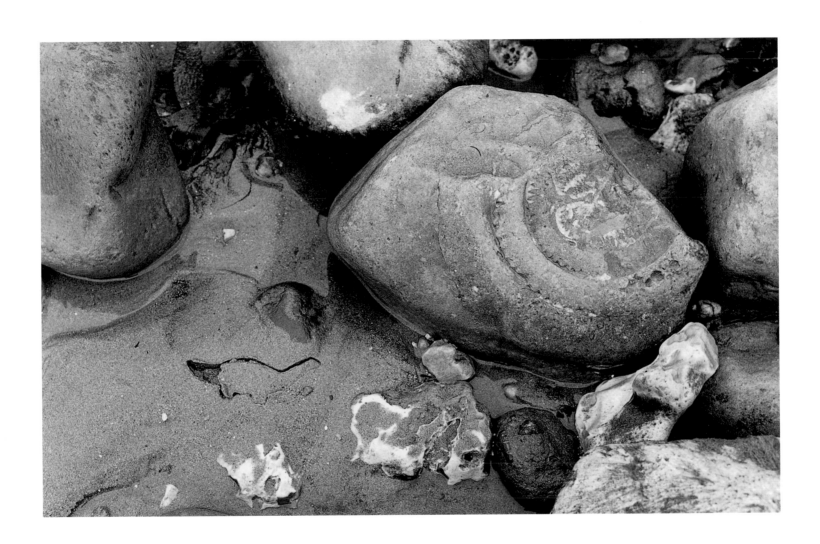

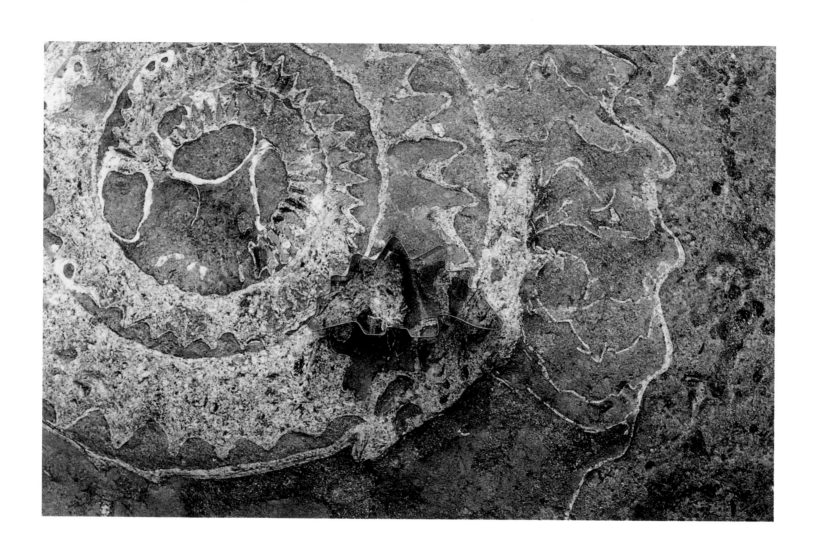

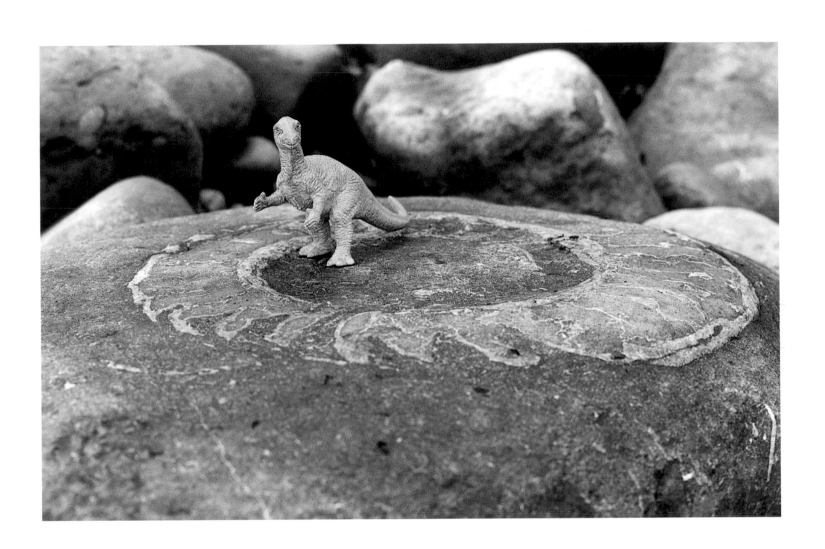

WILDERNESS DREAMS

Stevie Bezencenet

'Terra Incognita' was the term given to the unexplored areas of the North American continent and accounted for a substantial proportion of the country until the extended internal exploratory missions of the mid-nineteenth century. New Americans considered these unmapped areas to be without history and thus without meaning; they had as yet no signifiers and so were without significance, except in one respect – as wilderness. Wilderness was the 'unknown', it was fearful, exciting and with a potential as inexhaustible as it was vast. Wilderness called for explorers, for settlers, for industrialists – for action. It spoke to men's fantasies regarding themselves in relation to Nature and Nature in relation to God. Wilderness also called to artists, writers, philosophers, beckoning to those who wished to create signs to represent it, in their attempts to recognize its qualities, or 'subdue it' in the process.[1]

The 'Landscape' genre tends to present aesthetically pleasing images of natural scenes and Man's intervention in them, whilst serving the ideological functions of investigating philosophical and religious concepts – demonstrating social order, confirming ownership and affirming personal and national identity. The American wilderness offered an opportunity to create a landscape symbolic which met the cultural and ideological needs of a new nation, and one which aspired to escape what it perceived as the decadence of the Old World, of Europe. Could an apparently new type of space – 'Wilderness' – allow for the possibility of a new landscape form? Was it possible to 'escape' European visual language and the values it embodied? The concern here is with how landscape images were 'symbolically activated' in the inclusive/exclusive nationalist enterprise of creating 'imagined communities' in the mid-1900s in the 'New World' and how women in the 'Old World' have recently contested them.

WILDERNESS AND IDEOLOGY

'Wilderness' is an idea as much as a type of terrain. Whilst in nineteenth-century Europe it might signify an uncultivated area of only a few thousand acres, America was another story, for there it was the narrative potential of an apparently endless, virgin space which was particularly relevant for the ideas projected onto the wilderness. These ideas ranged from wilderness as dark, threatening, primordial, dense, chaotic – where man lost the advantage of his intellect – to Thoreau's belief that '... in wilderness is the salvation of the world' and Whitman's insight that it offered Man the chance to return to the 'naked source-life of us all – to the breasts of the great silent savage all-acceptive Mother'.[2] The traditional identification of women with Nature has enabled dreams of exploration, absorption, possession and control to be applied to the female body *or* a body of land with in/discrimination and familiarity. Here, fear of Nature's power, fascination and a desire for redemption combined to create an irresistible drive to penetrate America's interior under the banners of Nation, Race and God.

Wilderness was conceived of as an American asset – *the* asset, both morally and pragmatically. The nature worship of writers, especially the Europeans, Rousseau and Wordsworth, and the American, Emerson, and the influence of their ideas in American aesthetic and religious ideology contributed to the general conflation of America, Nature, God. 'Nature as wilderness was considered to have a restorative effect on men who were becoming overly civilized, the equivalent to being feminized' and, despite the Puritans fears of the dark and evil elements of the wilderness as they strove to transform the 'useless waste' and 'ungodly wilds' into a safe and 'sacramental space',[3] it was Romantic philosophy's idealization of Nature as the testing ground and Man as the heroic figure[4] which informed the religious, political and cultural rhetoric of nineteenth-century American society – as it continues to do. The American critic, Deborah Bright, proposes that 'the image of the lone, male, photographer-hero, like his prototypes, the explorer and the hunter, venturing forth into the wilds to capture the virgin beauty of Nature, is an enduring one' and that 'no less than Marlboro Country, American landscape photography remains a reified masculine outpost – a wilderness of the mind.'[5] Whilst there was a tradition of woman as homesteader, explorer and image-maker in America, it is one that is hard to unearth, for it has not been 'written into' the histories or the images in the continuous ways in which men's achievements have been.

By the mid-nineteenth century, landscape imagery in literature, painting, poetry and photography had become the

dominant symbolic for representing America. It had also become a dominant theme within discourses of science, politics, religion and philosophy – identification with the land, with American scenery, had become the way in which dispersed and divergent communities were encouraged to recognize themselves as part of a unified, national people. Since 'the New World was historically thin, its natural qualities – its scale, its newness, its variety – carried even greater importance';[6] geography stood in for history and scenery replaced culture, referencing future actions rather than those of America's unrecognized past. However, there were three prevailing ideologies in nineteenth-century America and they offered different philosophies of how to approach a country, a space considered to be 'inherently open-ended and unstable'.[7]

Primitivist ideology emphasized wilderness and set nature in opposition to the excesses of civilization, where nature and 'the noble savage' were associated with freedom, spiritual regeneration, authenticity and spontaneity, as opposed to the qualities of political tyranny, physical, economic and ideological oppression associated with European civilization.

Pastoral ideology took a middle ground, advocating an organized harmony between man and nature, where sufficiency rather than the European desire for surplus would prevail. This focus was prompted by a desire to retain the Arcadian dream and achieve Thoreau's idea of a pastoralism which would co-exist with the wilderness – this was to be a New Eden.[8]

Progressive ideology was essentially a utilitarian perception which considered American space as a potential to be absorbed in the name of Christianity and 'Progress'. Man's appropriation of Nature and all things natural was considered inevitable, including the extinction of native Americans. This doctrine of 'Manifest Destiny'[9] was acknowledged in the words of a settlers' guidebook: '... you look around and whisper "I vanquished this wilderness and made the chaos pregnant with order and civilization, alone I did it."'[10]

A POINT OF VIEW

It is interesting to consider what forms of order and control were offered by image-making, for it is these which concern us here, rather than a social history of American colonial expansionism. In America there was a strong working relationship between topographers, surveyors, painters and photographers on railroad and government expeditions, coastal surveys and military campaigns. The precision of measurement provided by surveying and photography was complemented by the sense of colour and atmosphere provided by painting. Their aim was the same – to offer an extended vision of what was previously invisible – to fill in those white areas of the map, still threatening in their immensity and yet infinitely desirable.

The maps and photographs, drawings and paintings which were created had the sense of being made by a 'disembodied eye', where the subject position was presented as neutral and outside the frame of reference. However, these perceptual and instrumental mechanisms for mapping perspectival space placed the observer in the centre, insinuating him as the originator of meaning and yet apparently innocent of its production. The desire to be situated, to locate oneself, is part of the desire to master one's environment: if the ego 'forms itself round the fantasy of a totalized and mastered body, which is precisely the Cartesian fantasy modern philosophy has inherited', then could we adapt Merleau-Ponty's idea that 'since the seer is caught up in what he sees, it is still himself he sees: there is a fundamental narcissism of all vision,'[11] and consider the environment as an extension of ourselves? This raises issues of who was doing the 'seeing', who was doing the 'identifying', who was creating the images and in whose interests?

Whilst America was conceived of as a *tabula rasa*, a virgin land waiting for man to make his mark on it and make marks about it, inevitably, this new phenomenon was approached with an already developed ideology. When we 'make sense' of a terrain, at that moment we are already caught by a cultural perspective which generates a way of seeing. The 'seen' becomes a 'scene' and our initial vision cannot be recovered, for once we have begun to weave narratives into the capacity before us, we move beyond our first innocent response, replacing it with a motivated gaze and carrying a determining set of cultural values. Only at first fleeting glance was the terrain ever an Eden.

Imagine this:

He needs to be bounded, to have a sense of the limits of his body in order to differentiate it from others. He needs to be high, to have a vantage point from which to project the widest possible cone of vision and embrace the greater space. He needs to be moving in order to progress from one encounter, one achievement, one narrative to the next. He wants to be challenged and not found wanting, and so will confront that which is both more than, and often less than, in his desire to achieve, to control and to subdue. He aspires to reason and endeavours to create structures of logic and order for all that he thinks and does. He wants to be master and to be transcendent; he needs to lose himself and he wants to find himself. His relationship to nature is complicated, but the impossibility of understanding causes him to make it in his own image – to create 'Nature'.

The Landscape tradition in Europe (dominated by the picturesque during the late eighteenth and nineteenth centuries) was linked to 'actual loss and imaginative recovery'[12] of a relationship to Nature which no longer

existed – but this was an aesthetic appropriated with optimism by American painters. A New World did not necessarily require a new language and the landscape symbolic was developed with vigour as Europe's representational conceits were brought into play in a new 'naturalism'.[13] As Nature 'became a supreme social value and was called upon to clarify and justify social change',[14] the picturesque's capacity to present a moral structure concerned with social order, found its perfect expression in the pastoral images of the 'middle landscape'. Such scenes provided the perfect opportunity to represent 'conflicts between freedom and order, change and continuity, growth and stability [which] could be rehearsed through spatial scenarios'.[15]

Landscape imagery offered the opportunity for establishing 'identity myths', attempting to represent America as a land of equal opportunity, whilst it more accurately documented 'the very process of exclusion [which] is integral to the nationalist enterprise';[16] the 'exclusion' in this case being non-white, non-male, non-landed inhabitants. Nineteenth-century American landscape painting and photography had an overriding set of themes, despite differences of subject matter, aesthetics or form: these were the drama of nature, the wealth of natural resources, man's heroics, the growth of settlement and the selective social processes which developed in order to maintain the progress of Improvement and the rolling back of the Frontier.[17]

Dominance is structured into these images in three ways: in the vantage point which the image accords the spectator, in the recording of man's control of Nature, and finally in the structuring out of social groupings without power. We can view a Connecticut pastoral scene from the vantage of Mount Holyoke with painter Thomas Cole, or consider the wilderness sublime with photographer Timothy O'Sullivan at Shoshone

Falls in Idaho; we can dream in Ralph Waldo Emerson's verse, or fantasize with the Frontier novels of James Fennimore Cooper – all these texts eulogize a relation to Nature which is in the service of white man's stories and his sense of self, his claim to a superior subjectivity and his right to dominance in thought, text and action. As President Andrew Jackson acknowledged in his inaugural speech in 1830:

What good man would prefer a country covered with forests and ranged by a few thousand savages to our extensive Republic, studded with cities, towns and prosperous farms, embellished with all the improvements which art can devise or industry execute?[18]

Imagine this picture:

It is 1868 and before us is a vast plain with mountains rising to the right, a river traversing their base and a scattering of deciduous and coniferous trees. The inhabitants of this wilderness are a herd of bison below the horizon, a single canoeist and two Indians on horseback. To our left is a developing town of wooden buildings, including a school, a station, a range of abodes and a camp of tents on the periphery. In the town, people are out and about, children are playing and a wagon train heads West. Most significant are two particular sets of activities: a group meeting a train in the centre of our panorama and a small group of axemen logging in the left foreground, one of whom gazes at the railway. The attention of the Indians, the axeman and most of the citizens is directed towards the railroad, whose tracks diagonally intersect the panorama from bottom right to top left – from our spectating position to the horizon.

This 1868 print by Frances Flora Palmer titled 'Across the Continent: "Westward the Course of Empire Takes Its Way"'[19] superbly demonstrates what was at stake in America's contesting ideologies, for whilst appearing to integrate the wilderness and pastoral promise into the scene, that which dominates the space is the railway, symbolizing technology

and action – 'Progress'. Progress literally cuts through primitive and pastoral America, offering the power of an unstoppable transformation – a transformation which is not only about technology, but also about who is in place and what their status is. The railway was the single most effective means of rolling back the wilderness and displacing the native Americans.[20] Not only did the Indian tribes literally disappear, exterminated until they formed less than 0.5% of the total population by the end of the century, they also disappeared from representation except for generally demeaning forms within popular culture. The settler/farmer would also be disenfranchised by the end of the century, by the power of industry and commerce to control the rewards for his labour. The 'transcendental Sublime' had become replaced by the 'enterprise Sublime'.[21]

If 'an identity implies not only a location but a duration, a history,' the absence of the recognition of such identity creates a void – one in history and another in the psyche. The endless repetition of specific perspectives and themes in representation and the omissions of others, served and continues to serve to naturalize white patriarchal power structures. Landscape imagery has traditionally offered the spectator the pleasures of an imaginary journey into representational space, creating the sense that in both the image and the material world we have the capacity of contemplation and of action, of affirming our sense of self and of creating our own narratives.[22] But the spectator which landscape imagery has conventionally addressed is particular, one who is thought to have the necessary qualities of broad vision and of a power to transform and to control – it is these qualities which are attributed to men. The fantasy of a New Eden did not seem to acknowledge an Eve, or if it did, it was an 'Eve' who was so identified with Nature that she rarely appeared as an actor in it.

MOMENTS WHERE PERCEPTION FOUNDERS

If America as a New World was unwilling or unable substantially to experiment with the 'language of landscape' to represent its ideas of a new society, and if, as a result, it continued to propagate an exclusive and Old World ideology of ownership and control, despite its attempts at a rhetoric of freedom and individuality, does this leave the social situation and the language inextricably bound up? We know that it is possible to play with signs over and above using them to confirm the status quo, and we know that language and visual texts can be used to interrogate, subvert and contest dominant ideas. There are many examples of women image-makers in America who have created work in the landscape genre which runs counter to the traditional images privileging man as the one who sees, who acts and who creates meaning in space. But what of women image-makers, women photographers in the Old World, who have a more established tradition of male ownership to contest – what new forms and rhetorics have they developed?

Imagine this series of photographs:

It is 1986 and we follow a white woman through a variety of locations: past a giant image of Mao Tse Tung, along the Thames in London, standing outside a factory, in winter woods and near a summer cornfield – she is always turned away from us, managing to stand within the setting so that our own gaze is disrupted by her, sometimes abruptly, sometimes imperceptibly, but always actively – even though she is quite still and never acknowledges our presence. Who does she think she is? What gives her the right to interfere with our visual field?[23]

Imagine this single photograph:

It is 1987 and we are in the Lake District in England, centre of the Wordsworthian picturesque. Dressed for walking, a young black woman stands alone, staring off into space. She is surrounded by space and the segregation of space, by stone walls, trees and roads. She looks out over a view we cannot see, though there is another behind her – an ordered landscape, referencing agricultural and cultural wealth. We notice that she is coloured in, two-dimensional and fixed, without the capacity to move freely or identify with her surroundings. Is she thinking the text which accompanies her image?

… it's as if the Black experience is only lived within an urban environment. I thought I liked the LAKE DISTRICT, where I wandered lonely as a BLACK face in a sea of white. A visit to the countryside is always accompanied by a feeling of unease, dread.[24]

Imagine this work, each frame dissolving into the next:

It is 1995 and we are transported to another landscape, where we are presented with a conundrum – an interrogation into time, space and intention – by a woman who negotiates a panorama of large dunes. She appears to be performing for the camera, and for us, but to what purpose? As we watch she plays with her surroundings, childlike and rolls down the side of these gigantic slopes, throws the sand high in the air, climbs and rolls again and again, suddenly appears on the skyline, nearer, further, lies down, the light changes, she is distant and then erupts in the front of the frame, as if she had been buried almost beneath our feet. She destabilizes us, for she refuses to acknowledge our point of view. She manages to make herself in/distinct from her environment and as the repetition continues the work keeps us enraptured/trapped for there appears to be no reason, no story, no closure – instead a forever of engagement. She calls herself the Deserter, but what has she abandoned?[25]

These three photographic works by Susan Trangmar, Ingrid Pollard and Marion Kalmus are viewed in the context of an old culture – one which has privileged a 'rational' white male ideology and its accompanying gaze for centuries. We know it is not possible to completely re-invent sign systems, however much we may strive to do so, and despite post-structuralism's insistence on the slippery nature of language, we still require a set of shared signs in order to communicate. But we can interrogate or fracture the taken-for-granted concepts and values which have historically informed our visual ideology, through experimentation with new language forms.

Landscape has long been considered to be linked to 'actual loss and imaginative recovery', in the Edenic sense already discussed. However, there is another way in which we can interpret this phrase – from the position of those who desire to investigate their sites and situations of displacement (loss) and play with new vocabularies and visual structures (imaginative recovery). These three photographers have posed the following questions: how can Landscape work encourage awareness of processes of identification? is the right to view/to be in place shared equally? can the acquisition of space and the opportunity to make one's narratives there be self-determined? Our real relation to space and our representation of space are linked issues. If we borrow an idea from the concept of wilderness – the space without prior meaning – and relate it to traditional 'landscape language', is there now a possibility of creating a new type of symbolic? If we borrow the idea of violence which has been applied to the transformation of nature and apply it to language itself, is it time for a more disruptive approach, for 'moments in which perception founders'[26]? Is it for a new in/coherence?

EPILOGUE

Imagine this:

She dreamed an image. It was visually clear in her mind, if conceptually murky. It is dusk and a naked woman stands facing away from the viewer to one side of a small glade. The trees are old in this

coniferous wood and there is a space in the centre of the image which waits to be filled. She waits, we wait ... nothing happens. While we wait the image grows gradually exquisite, combining a clarity of detail with the impression of becoming something else ... something more than just an image. A sense of absolute stillness, and then, with no warning, the vacant space in the image violently explodes – the surface of the photograph ruptures outwards, its flat calm destroyed. The onlooker falls back startled, under attack. The woman, still to one side, has not moved, but waits, paying no attention to the violation of time and space which has just occurred – to the arbitrary destruction of her scene. Paying no attention to me, or even to you. But now there is a gape, and a garble – the stirrings of some questions. Do they have a language to give them form? We don't know.

ENDNOTES

1 In *American Painting of the Nineteenth Century* (New York: Harper Row, 1979) p 160, Barbara Novak proposes that the artist's 'nature' had already been 'civilized' by art history, 'in its way as potent a challenge to the primordial wilderness as the axe'.

2 Thoreau quoted in Miller, Angela, *Empire of the Eye* (London: Ithaca, 1993) p 18. Whitman quoted in Jussim, Estell and Lindquist-Cock, Elisabeth, *Landscape as Photograph* (New Haven and London: Yale University Press, 1985) p 36.

3 Nash, Roderick, in *Wilderness and the American Mind* (London, Newhaven: Yale University Press, 1982) p 31, proposes that the attitude of early American settlers was that 'wilderness was waste; the proper behaviour toward it, exploitation,' referencing the Bible, *Genesis* 1:28: 'Increase and multiply, replenish the earth and subdue it.' The idea of sacramental space is from Hughes, Robert, *American Visions: the Epic History of Art in America* (London: Harvill Press, 1997) p 24.

4 In Jussim, *Landscape as Photograph* p 29, the authors discuss John Ruskin's concept that 'true landscape' required the presence of man or 'heroes', for without them 'it will cease to be romantic.'

5 Bright, Deborah, 'Of Mother Nature and Marlboro Men: An Inquiry into the Cultural Meanings of Landscape Photography' pp 137-8 in Bolton, Richard, (ed.) *The Contest of Meaning: Critical Histories of Photography* (London: MIT Press, 1990). She critiques the idea that men are distinct from nature choosing to manipulate it literally and symbolically, whilst women are nature and cannot define themselves in opposition to it.

6 Miller, *Empire of the Eye* p 7.

7 Miller, *Empire of the Eye* p 11. Miller discusses here the ordering processes of landscape imagery and how this mechanism served to make Nature's excess acceptable.

8 Hughes, in *American Visions: the Epic History of Art in America*, discusses in the Introduction how 'newness' became a sign of integrity for early American settlers and was thus the country God had chosen to fulfil His designs. He later suggests that by the nineteenth century Eden lay to the West as 'Nature became America's national myth and the act of painting it an assertion of national identity,' p 138. See also Nash, *Wilderness and the American Mind* pp 16 – 19 and Bermingham, Ann, *Landscape and Ideology: The English Rustic Tradition, 1740 – 1860* (London: Thames & Hudson, 1987) p 67.

9 See Hughes, *American Visions: the Epic History of Art in America* pp 189-190 for a discussion of Manifest Destiny as 'America's myth of redemptive violence. It created its own heroes; and art had a large role in promoting it.'

10 Quoted in Nash, *Wilderness and the American Mind* p 42.

11 Merleau-Ponty, quoted in Grosz, Elizabeth, *Space, Time and Perversion* (London: Routledge, 1995).

12 Bermingham, *Landscape and Ideology: The English Rustic Tradition, 1740-1860* p 11.

13 Naturalization: the process by which bourgeois realism structures and codes its institutions and representations as 'natural' and in and through which individuals are encouraged to recognize themselves and their place in the social order.

14 In her Introduction Bermingham (*Landscape and Ideology: The English Rustic Tradition, 1740-1860*) discusses how concepts of 'nature' and the 'natural' became applied to processes of change in the eighteenth and nineteenth centuries.

15 Miller, *Empire of the Eye* p 14. See also Hughes, *American Visions: the Epic History of Art in America* p 203, for comments on the nineteenth-century illustrator Frederic Remington: 'His entire imagination revolved in a naive way, around the vision of an Arcadia of noble violence, a ... world of frontier conflict, of displacement, and, in the end, of loss.'

16 Daniels, Stephen, in *Fields of Vision* (Cambridge: Polity Press, 1993) pp 5 & 33, links 'identity myths' to imperialist nationalism, and considers how American communities have been disenfranchized in this process.

17 Rudzitis, Gundars, *Wilderness and the Changing American West* (Chichester, 1996) p 6. Rudzitis defines the Frontier as the 'meeting place between savagery and civilization', which was pushed back from the East to the Pacific throughout the nineteenth century. Given the ideological investment in this concept, it is curious that the Frontier was considered 'closed' in 1890 after a Government census determined that there were more than two *white* inhabitants per square mile – its threshold of definition. Was this a moment of crisis for America, or did no one notice? Did the novels, songs and films of popular culture preserve the imagined Frontier whilst Wilderness Parks were established to conserve the diminishing areas of 'unstable space'?

18 Quoted in Nash, *Wilderness and the American Mind* p 41.

19 There is an extended discussion of this print in Daniels, Stephen, *Fields of Vision* (Cambridge: Polity Press, 1993) and Born, Wolfgang, *American Landscape Painting* (London, New Haven, Yale University Press, 1948). By the mid-1900s the Frontier came to mean the Western States of America: Horace Greely, Editor of the *New York Tribune* suggested in 1865: 'Go West, young man, and grow up with the country.'

20 There were over 30,000 miles of American railways by 1860. At the end of the Civil War in 1865 the transcontinental railroad was begun with the Union Pacific line heading West from Omaha and the Central Pacific line heading east from California. Daniels (*Fields of Vision* pp 182-4) describes it as 'a large scale corporate enterprise with a distinctly military regime', suggesting that 'the railroad became the primary embodiment of heroic virtue.' It enabled expansion and improved the potential for violation. For an extensive discussion of the effects of technology in

America, see Nye, David E., *Narratives and Spaces: technology and the construction of American culture* (Exeter: University of Exeter Press, 1997).

21 Edmund Burke's treatise of 1757, *A Philosophical Enquiry into the Origin of Our Ideas of the Sublime and the Beautiful*, proposed that the 'Sublime' was the awe-inspiring element in Nature. Thomas Cole founded the Hudson River School of painting in 1825, excited by the fact that 'All nature here is new to art.' However by the 1840s he had coined the phrase 'the enterprise sublime', believing that America had betrayed its wilderness by its technological 'Improvement' of Nature. See also Miller, *Empire of the Eye* pp 56-69, for a discussion of Cole's painting and his role in developing a 'romantic sublime'; Daniels, *Fields of Vision* Chapter 5, 'Thomas Cole and the Course of Empire'; and Novak, *American Painting of the Nineteenth Century*. Cole's own 'Essay on American Scenery' can be found in *The American Landscape: A Critical Anthology of Prose and Poetry* (New York, 1973) pp 568-78.

22 Miller, *Empire of the Eye*, p 83: '... story there must be or we have no landscape' (quoting an 1849 critic).

23 Reference to Susan Trangmar's photographic series 'Untitled Landscapes 1986', discussed in the essay 'Shifting Focus' by Susan Butler, in Butler, Susan, *Shifting Focus* (London: Arnolfini/Serpentine 1989).

24 Reference to Ingrid Pollard's 'Pastoral Interlude', 1987 – 8, an image-text photographic series, which is discussed in the chapter 'Wastes and Boundaries' in Taylor, John, *A Dream of England: Landscape, Photography and the Tourist's Imagination* (Manchester: Manchester University Press, 1994) and in the exhibition catalogue *The Cost of the English Landscape* (Newcastle: Projects UK/Laing Art Gallery, 1989).

25 Reference to Marion Kalmus' work, 'The Deserter', 1995. This was first exhibited at the 'Video Positive' festival, Liverpool, 1995.

26 Jackie Rose, quoted in Rose, Gillian, *Feminism and Geography* (Cambridge: Polity Press, 1993) p 103, discusses Freud's writings on the 'complexity of an essentially visual space' in our identification with images.

MICHELLE ATHERTON

Park

Park explores areas in terms of their simultaneously benign and threatening status. On first viewing, these large photographs (30 cm x 100 cm) appear as excessively familiar images of parks. On closer inspection it becomes apparent that the park lights are illuminated. The viewer is then faced with a temporal contradiction as the photographs appear to be depicting day and night. This undermines the indexical character of the photograph. An air of disquiet is added to the images that points towards an altogether more unsettling narrative.

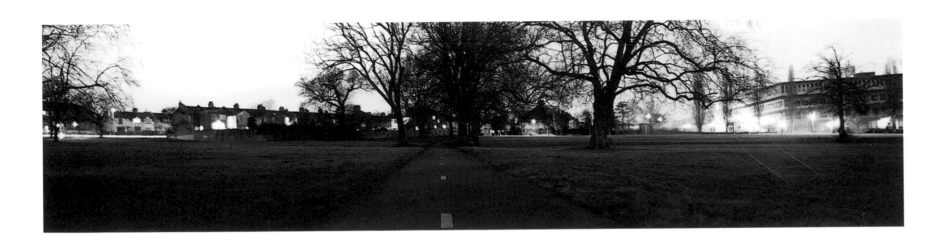

oo.o5am

01.47am

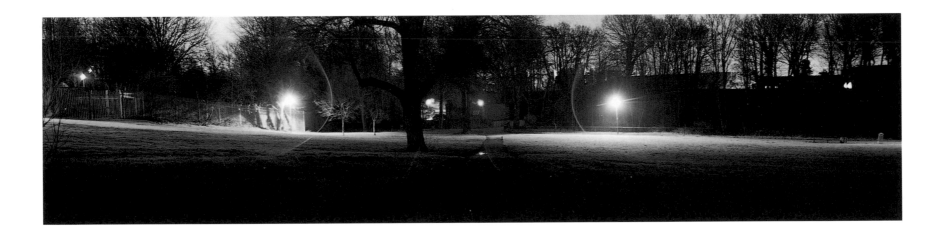

02.23am

SALLY WATERMAN

THE WAVES

Now is life very solid, or very shifting?
<div align="right">

VIRGINIA WOOLF, diary, 1929
</div>

As a modernist text, Virginia Woolf's *The Waves* dispenses with the traditional forms of the realist novel. Through their fragmented streams of consciousness we trace the development of six characters, a group of friends, from childhood to middle age. Here, photographic images echo moments in the novel, drawing attention to central existential issues of identity, reflecting the all-pervading sense of English melancholy associated with Woolf's own preoccupation with life and death and the complexities of human experience.

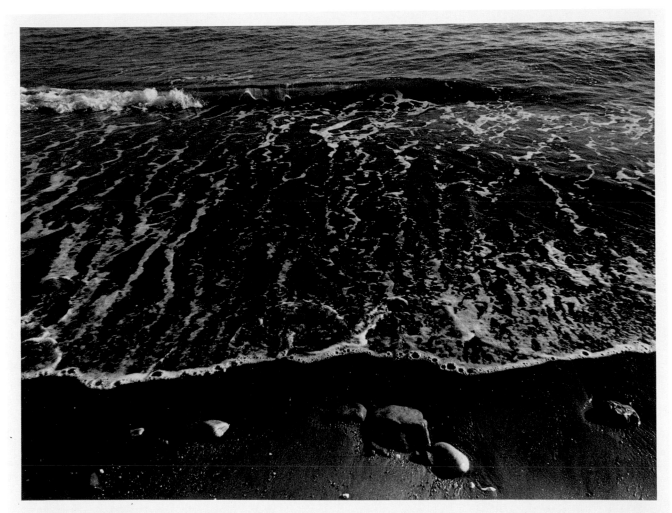

Blue waves, green waves swept a quick fan over the beach. One after another they massed themselves and fell; withdrew and fell again.

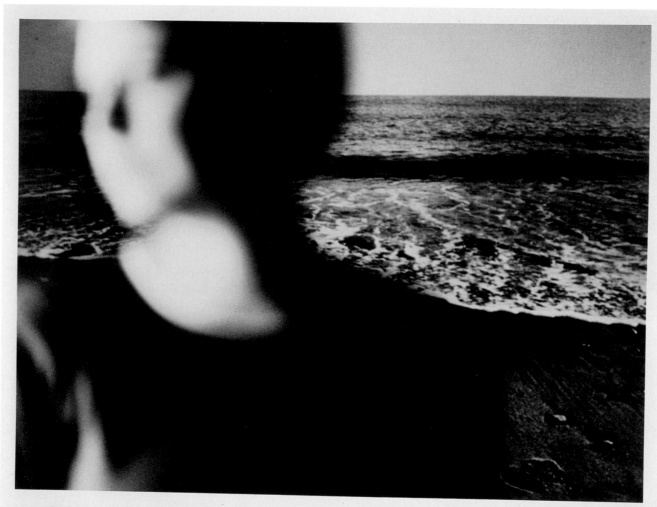

Like a cork on a rough sea, the wave breaks. I am the foam that fills the uttermost rims of the rocks with whiteness And I have no face.

Life is tolerable; pain is absorbed in growth. We are swept on by the torrent & things grow so familiar that they cast no shadow.

The train slows and lengthens as we approach London. I am about to meet – what? I will sit still one moment before I emerge into that chaos.

I like the passing of face and face and face, deformed, indifferent. I ride rash waters and shall sink with no-one to save me.

We may sink and settle on the waves. The white petals will be darkened with seawater. They will float for a moment and then sink.

These roaring waters upon which we build our crazy platforms, like a long wave, laying bare the pebbles on the shore of my soul......

LANDSCAPE OF IMMINENCE:
BRENDA PELKEY

Martha Langford

'Oblivion' is an impertinent title for a body of photographic work. *The state of being forgotten? The state of forgetting or of being mentally withdrawn? Official disregard, or overlooking of offences; pardon; amnesty?*[1] No dictionary definition seems to fit. The denial of memory is the stumbling block. If photographic meaning has shifted off centre, or if the photograph as document has lost some of its official lustre, the link between photography and memory has only grown stronger in the process. We have redefined both memory and photography by analogy and family resemblance. Photographs and memories fade. Photographs lie, and memories are false. But the idea of memory still carries a certain authority, and the photograph does too. Memory, as opposed to history, rings true for us now as an unauthorized version of events, something an elder told us, a seed turned over and over with our tongues until it sprouted in our own words. The photograph likewise germinates stories, reproduces itself from a matrix of inconclusiveness. Memory (photography) is porous (translucent), immediate (transparent), and fecund (multiple). Photographic memories, as we understand them now, are likeably flawed, unstable, possibly badly fixed. But we trust the patchiness of frayed connections, we respond to their stuttering power as somehow corresponding to a consciousness of the past. And Brenda Pelkey does not? Well, she calls her recent series 'Oblivion'.

Such independence is not out of character for an artist who in 1994 challenged the received idea of photography as language by characterizing her photographs as 'mute'. Close

and multiple readings of surface reality did not yield deeper meaning – that was her argument. She herself was not being informed. What she was interested in exploring was the 'untold and unable to be told', a curious departure, you might think, for a former documentary photographer.[2]

Brenda Pelkey's work was then, as now, hard to classify, or calcify, in any genre. Her tools and talking points, even at the height of her so-called documentary phase, were theatrical. In its current manifestation as landscape, her practice lives somewhere on the outskirts of photography as a combination of prints, texts, and tapes. She switches, or seems to switch, between autobiography and fiction; her sense of place has a cinematic air. She is sceptical of heroes, her actors are extras. Few of us care much any more about purity of medium or form, but Pelkey's unconventionality indicates more than fashion. In fact, it indicates the opposite: a lifetime aversion to categories or cadres, especially in art; a complementary interest in sidebars and unofficial stories.

Always in her work is a pull to the outsider, with the attendant desire to pull him or her inside-out. In '... *the great effect of the imagination on the world*', a series of panoramic assemblages from the eighties, Pelkey began to experiment with the psychic landscape, her test case the fantasies and obsessive natures of those neighbourhood pariahs who decorate their lawns. Flamingos and whirligig daisies are the low end of this cottage industry which has spun theories from folklorists, historians and critics. Pelkey was naturally most interested in how the phenomenon might be framed as

a picture. Restricting herself to Saskatoon's urban lot, she found outstanding examples of private theme parks which she heightened dramatically by photographing at night with movie lighting and splitting the view into a fragmented panorama. These energized landscapes were also portraits of the artists, folk somewhat dwarfed by the magnitude of their enchantment. Their religious shrines and world-making pastiches, shining out of the dark, were taken by Pelkey as expressions of internal realities, states of being rather than social statements of kitsch and outsider economies. The story that Pelkey was after was an old one, the archetypal expression of the subconscious. She serialized this *Hansel and Gretel*, shifting thereafter to the Grimm workings of her own mind.

The setting remained the outdoors, with one wrenching exception, a work from 1993 entitled 'Love'. Through 'Dreams of Life and Death' (1994), she continued work in and around Saskatoon. 'Memento Mori' (1996) and 'Oblivion' (1997) took Pelkey away on photographic expeditions (necessitating a caravan of lights, generators, and a sanguine assistant) to the Maritimes, beginning with places remembered from her childhood. Only some places, for Pelkey was a child of the Canadian military and her family moved around in Canada and Europe. The place that she identifies as home is where she first struck out on her own, living away from her family. That was Havre Boucher, Nova Scotia. As she explained later to curator and writer Cindy Richmond, her return after 20 years to Havre Boucher

BRENDA PELKEY

'Yard', from the series 'Dreams of life and death' (original in colour)

1994

I never knew that he beat her

She wept in my kitchen

She was away. I looked after the children.

He came home drinking. We all got in the truck

and drove for hours in the night

to the homes of strangers.

I can only remember clearly the next day.

2 pieces: 50 x 40 inches, 50 x 30 inches

Ilfochrome, mounted on sintra

BRENDA PELKEY

'Telephone Booth' (original in colour)

1994

No one knew why he killed himself. He was engaged to be married

and had just built a house.

He borrowed a gun from a cousin.

Two weeks previously he had invited me to go to see his new house. I had admired the

kitchen taps, and seen the bedroom where he later died.

When we had dated briefly he told me he would not live beyond thirty.

I thought perhaps he had been influenced by 'the movie'.

He always honked his truck horn when he drove past telephone booths.

He told me that the person could be talking to someone in Ontario and his truck horn

would be heard in Toronto.

3 pieces: total dimension 40 x 81 inches

Ilfochrome, mounted on sintra

BRENDA PELKEY

'Bush' (original in colour), from series 'Oblivion'

1998

Audio: ... goodbye ... goodbye ... goodbye

3 - 40 x 50 inches

Ilfochrome, mounted on aluminium

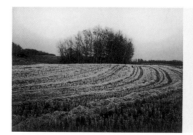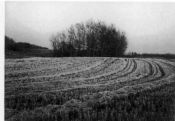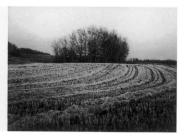

precipitated a rush of autobiographical memories and tragic associations. Once home, she incorporated those feelings into a suite of elemental landscapes.[3]

The photographs are very simple. Their 'great effect' is the eerie illumination that Pelkey had developed with movie lights in the dark. Also retained is the fragmentation of the image into three or four panels, one now considerably smaller, isolated from the assemblage, and overlaid with text. By any rule, and especially by comparison with the decorated gardens, these are restrained compositions. 'YARD' (1994) is little more than the flash of headlights on a white clapboard façade and an aluminium door, car bumpers and grilles, the back of a red pick-up truck, the outline of a shed and an unclipped hedge. Brilliance and deep shadow alienate these elements from each other. None of it, in any case, seems real. The foreground, a driveway strewn with brown leaves, is extended into the text panel, an arboreal setting for the following:

I never knew that he beat her.

She wept in my kitchen.

She was away.

I looked after the children. He came home drinking. We all got into the truck and drove for hours to homes of strangers.

I can only remember clearly the next day.

I-he-her-she-she-I-he-we-I-the children and the strangers. A little snapshot of private life, a little violence, a few tears, a little craziness, a little risk, a little remorse – episodes witnessed or imagined by the artist, and recalled ever after by exposure to a certain constellation of elements, by a certain *type* of site.

The connection between landscape and memory has been explicated by such writers as Raymond Williams and Simon Schama, cultural historians prompted by physical signs and incomplete knowledge of their own histories.[4] Reading John Clare, Williams recognizes his own attachment to place, understands the loss of 'Nature' as 'the loss of a specifically human and historical landscape, in which the source of feeling is not really that it is "natural" but that it is "native"'.[5]

The same connectedness shapes Lucy Lippard's *The Lure of the Local*, making itself visible in the autobiographical text that runs across the top of her book as the writer's voice, her personal register.[6] Pelkey's nocturnal landscapes are singular indeed, but their cinematic force strengthens the viewer's implication in ways that come clear in 'Dreams of Life and Death' in a work, for example, like 'TELEPHONE BOOTH'.

My reception of the work translates into a retelling. It goes something like this. Imagine yourself at some mid-point in life, home after the usual kind of dulling day, and you're dulling yourself still further by watching something on TV, when you remember that there's not enough milk for the kids' cereal. Complaining, though secretly pleased, you rise from your chair, grab your wallet, and head out to the local store. You drive because you're kind of tired, and your mood right now wants to skim along rather than gaining some cardiovascular credit from what you have seized from a shrinking quiver of straws as a private moment, a chance to be alone, and neither exercise, nor think. You pass a brightly lit telephone booth, and it freezes as a standing stone on the mid-point of your horizon, the whole scene set up by the gods to throw you back to something you haven't thought about for years. You don't stop, you keep driving because you've gotten everything you needed at a glance. That for me is the picture and this is Pelkey's text:

No one knew why he killed himself. He was engaged to be married and had just built a house.

He borrowed a gun from his cousin.

Two weeks previously he had invited me to see his new house. I had admired the kitchen taps and seen the bedroom where he later died.

When we had dated briefly he told me that he would not live beyond thirty. I thought perhaps he had been too influenced by 'the movies'.

He loved to honk his horn while driving by telephone booths. He told me that the person could be talking to someone in Ontario and that his truck horn would be heard in Toronto.

The wide screen that is the picture, the turquoise spill of light across the asphalt, the human scale of the booth, the triumph of sound over time and space in both image and text: photographs and stories together always play with degrees of presence and pastness, but this set of moves is particularly adept. Pelkey is grappling with a calamitous event by placing before the spectator a full spectrum of ordinary, and clearly happier, possibilities, the 'what if's' that make the final outcome so cruel. Michael André Bernstein has presented a model for this way of thinking (his example is the Shoah), insisting on what he calls 'the prosaics of the quotidian' to give contour and shadow to lives flattened by a catastrophic event. If this is history as speculation, if these memories are unrealized, they are no less attached to the real, as Bernstein explains in the most graphic terms: 'Only the brightness of an actual event can cast sufficient shadow for sideshadowing to matter, and only the felt force of a life can give impetus to the counterlives that seize the imagination'.[7] This is also the beauty of Pelkey's work, that it crystallizes the terrible moment in its many points of promise and reflection. Her work muses and meanders through time and place in a very human way, at once vulnerable and defended.

Brenda Pelkey

'Path' (original in colour)

1999

When told of her son's death by drowning
She cooked his dinner and waited for his return

50 x 40 inches

Ilfochrome, mounted on aluminium

Work gathered under the titles, 'Memento Mori' and 'Oblivion' further refines this conflate style. More romantic in subject matter and composition, the landscapes refer to forests, country roads and the sea, some affixed with the place names of Nova Scotia and the Shetland Isles, layers of pastness in these toponyms alone. The photographic treatment is Pelkey's remarkable formula of enrichment – the darkness, the lights – which at The Photographers' Gallery in Saskatoon was enhanced by installation on inky walls. In some of the 'Memento Mori', a separate text panel of white letters on a black field hangs below the pictorial image. In 'Oblivion', the texts are no longer separated from the main panels but emanate from the image, as though part of its natural rhythm. As ever, beauty and calamity intertwine.

The stories that seem to haunt these fields and shorelines are first-person accounts of death by sickness and disaster. Tenderness and torment, avowal and shame, shape gothic expressions of longing:

His love had been larger than any she had ever known

she keeps his boots still lined up by her bed

As he was nearing the final stages of his illness

her ex-husband shot and killed his dog

Whose love story is this? We don't know. All we see are deep ruts in white gravel, a bright-lit road to blackness lined with greenest and brownest of evergreens. We are told that these stories were told to the artist by the women of the district. Pelkey's recollection of the stories is naturally more central to our interests as we contemplate her work. If children's nonsense rhymes and survivors' tales of the sea haunt her work, they have touched her, or scraped at her more likely, because they echo and predict the circumstances of her own life. In the women's circle of spin-storying, she hears their stories and I hear hers in her pained and partial repetition of words and images.

'Bush' (1997) brings Pelkey's melancholic participation very near. The photograph, thrice presented on a horizontal line, is a long view of a cultivated field whose lines curve into the backdrop of a gently rounded screen of trees. The setting sun naturally blends the colours – the ochre field rusted, the thicket warmed to grey, the sky a vestigial blush. The effect is soft and sensual. Detail has been restrained to the absolute minimum, updating an impressionistic style that some nineteenth-century photographers believed to be the true representation of vision; French calotypist Gustave le Gray suggestively urged a principle of 'sacrifice'.[8] The sacrifice inferred by 'Bush' has a sharper edge. There is no text until the spectator approaches and hears it spoken. The voice of woman, pulsing like the images, like a heartbeat: 'Good-bye.'

Pelkey's 'Dreams of Life and Death', the chronicles of 'Yard' and 'Telephone Booth', are the antitheses of screen memories, for they offer no shelter or substitution, but rather the blinding flash of memory as a composite of dashed hopes and dumb facts. What is remembered, what is inhabitable only in memory, is a place that existed only in the imagination, a fiction too ephemeral to last, too prosaic to memorialize. The 'Memento Mori' are more direct expressions of grief and yearning, lived, seen, heard, walked and driven into the landscape by Pelkey's informants, the women up ahead. They are performative works, theatres of unspeakable common knowledge. 'Oblivion' signals the condition of memory suspended, a state of wilful forgetfulness of what will be. The experience is both exulting and terrifying – the ordinary and the particular striking with the force of the sublime.

Narratives of life, death and in-between are strewn across Brenda Pelkey's landscapes of imminence. Lovers and tellers feel their way toward the void.

ENDNOTES

1 *Webster's unabridged Dictionary of the English language* (New York: Portland House, 1989).

2 Pelkey, Brenda, 'Artist's Statement' in Gustafson, Paula and Williams, Carol, *Search, Image and Identity: Voicing Our West* (Saskatoon: The Photographers Gallery, 1994) p 53.

3 Richmond, Cindy, 'Picturing-Home', *ARTSatlantic* 60 (Spring 1998) pp 36-40.

4 Williams, Raymond, *The Country and the City* (New York: Oxford University Press, 1973) pp 1-8; and Schama, Simon, *Landscape and Memory* (Toronto: Random House of Canada, 1995) pp 23-36.

5 Williams, *The Country and the City*, p 138.

6 Lippard, Lucy R. *The Lure of the Local: Senses of Place in a Multicentered Society* (New York: The New Press, 1997).

7 Bernstein, Michael André, *Foregone Conclusions: Against Apocalyptic History* (Berkeley, Los Angeles and London: University of California Press, 1994) p 7.

8 See James, André and Janis, Eugenia Parry, *The Art of the French Calotype* (Princeton: Princeton University Press, 1983) pp 96-101.

An earlier version of this essay was published in *Border Crossings* 17:4 (Summer 1998) under the editorship of Meeka Walsh. The author is pursuing her research on photography and memory as a post-doctoral fellow with the Institute for the Humanities of Simon Fraser University, thanks to the Social Sciences and Humanities Research Council of Canada.

LIZ NICOL

THE RUBBER BAND PROJECT IV

The first project began close to home, on my daily walk with my eight-year-old son Charlie. This journey to school was marked by the number of rubber bands we found; it mapped a relationship. The activity was outside; with our eyes scanning the streets, we observed the pavement as a surface – how for example Autumn leaves drenched by rain and dried in the sun left their trace, like a photogram. This initiated the idea of working with the cyanotype, the wonderful blue print.

The prints were made inside, at home; generally late at night. Rather than working with sunlight I used a domestic sun-bed as the source of ultraviolet light needed to make the prints/photograms. The visual quality was much softer, like a memory of the object/rubber band that had been placed on top of the coated paper.

Why Stoke-on-Trent? In response to the first project, I was asked by the curators to make pieces that related to the location where the work would be exhibited. I found myself preparing for the visit as one would a field trip; poring over maps, planning routes etc. Looking through the index of street names for Stoke-on-Trent, I started to pick out

plant/flower names. The prompt was Iris Close (relating to IRIS – The Women's Photography Project). I continued picking out my favourites: Magnolia Drive, Fern Place, Lillydale Road, Foxglove Close, Rose Street, Ivy Grove, Lavender Close and Moss Street.

So I set off on the journey with associations based on names, with anticipation and some trepidation. It was Tuesday, my research day, – why was I travelling all this way to collect rubber bands? My map reading didn't please the driver and visibility was bad. The mist was wet and cold, it continually felt as if it was about to clear but it didn't.

The activity of walking up and down streets collecting rubber bands is more remarkable when you don't have a child with you. As we got out of the car around the corner from Lavender Close, I heard someone's front door lock, houses were boarded up, it was grey and dismal. Several of the streets named around the flower theme were part of this estate; much the same as you would find in any city.

A young man came out to see if we were looking for keys that had been lost recently; it broke the ice, 'no, my girlfriend's an artist, she's looking for rubber bands.'

Moss Street III

Fern Place I

Magnolia Drive I

Lillydale Road IV

Iris Close

SU GRIERSON

'SCENARIO'

In this current project 'Scenario' I look at the land and our relationship with it, through the direct intervention of technology.

Change has always been here, in the land, but modern disruption to the rhythms of change creates fear and uncertainty. I see uncertainty, not as a point to turn away from but rather as a place to be worked through.

By using the 'low point' of technology – the point where it hovers around collapse – and colliding this with 'real' video images of land, I have forged a new space, it lies in the interval between the lens-based analogue image and the digital computer system.

The instability of the technology adds a sense of uncertainty and disturbance to the images, to the places we recognize as real. The figures in the landscape have a feeling of impermanence, of passage, they exist there for the moment only.

I use technology not for itself but as a tool for *re-looking* at the land and our place within it. Bringing together the real and the virtual.

Virtual worlds, whether philosophical, imaginative or technological, offer ways of *re-seeing* the real, creating scenarios of what is and what might be.

Disturbance, challenge and new energy are found in the way we look at things. *Re-imaging. Re-imagining.*

Journey (From Analogue to Digital)

Video footage of a high speed car ride through mountain and clifftop landscape – a filmic device suggesting fear, danger and chase – is given a fast ride through the technology.

Moving on fast-forward between analogue and digital formats, the 'real' image collapses into a slur of broken shapes and colour. Moments of this new journey are captured with computer software.

Information, order and 'reality' are converted into a virtual stream of sensation and imagination.

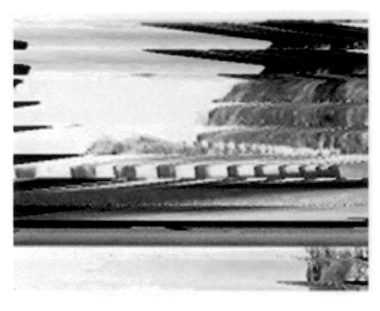
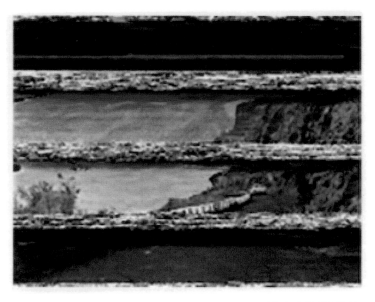
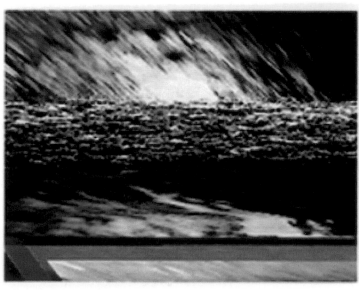

Out there/In there

When analogue video is input to digital computer, systems collapse. Collapsing technology inserts default colours, electronic interference and vibrant colour inserts. The image in *Out There/In There* has been captured on this cusp between the two formats.

Alongside the images a video plays. A short, looped sequence of the same figure apparently trapped in a thicket of bushes. Constantly dissolving and re-appearing, contained in a cycle of constant repetition.

No longer is the land seen through the dominant eye of the viewer, here the figure is united with the location and has no more than a personal spot to stand on in the greater expanse of landscape.

Technology offers the interface, the distance, that enables us to see and to re-imagine ourselves in relation to the land.

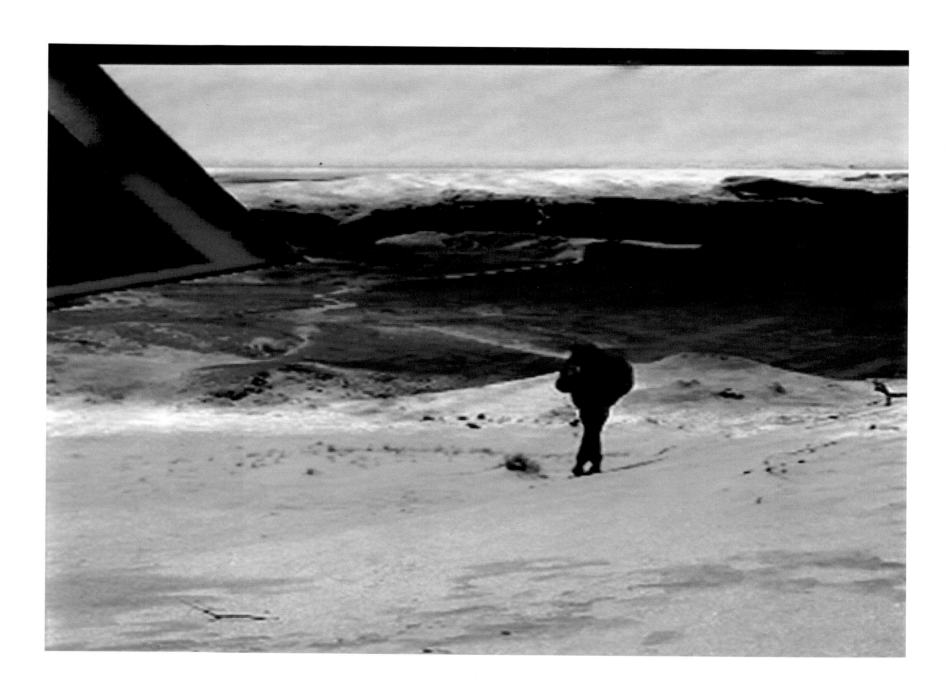

LADIES AND THE LANDSCAPE

Sue Swingler

Landscape photography! How pleasantly the words fall on the ear of the enthusiastic photographer.
What agreeable associations are connected with our excursions in the country. How often have we wandered along the rough sea-shore
or climbed the breezy hill-side, or descended the shady valley, or toiled along the rock-bed of some mountain stream, forgetting in the
excitement of our pursuit, the burdens we carried, or the roughness of the path we trod![1]

Women might have been in the audience addressed by James Mudd in Manchester, but it is unlikely that many of them would have shared this kind of experience of photographing the landscape. However, women had been involved in photography from the early days, as amateurs and members of clubs and societies. A few women saw themselves as professional photographers, and Lady Eastlake[2] was a significant writer and theorist on photography. Generally, though, women's public participation in photography was insignificant – even by 1895 there were only ten women members of the Royal Photographic Society from a total of about 470. Historical collections include examples of women's work, and photographic histories discuss it, but chiefly it is portraiture that is considered. Rarely do we see examples of landscape photography by women until after the First World War.

In seeking out landscape photographs by women I have looked at public archives and private collections, and most of the work offered as examples here would have been considered by the photographers as personal and amateur, originating as it does in family albums. The albums range from the 1850s when Lucy Bridgeman, daughter of the Earl of Bradford, was taking photographs in and around her family home at Weston Park, to the 1920s when Alex Dowdeswell was documenting life at Wick Court in Gloucestershire, an estate she farmed with her brother and sisters. These are albums that combine family portraits with photographs of social occasions at home and on visits to other, usually grand, country houses. Other albums are more specifically focused, recording holidays or visits abroad. In this category are the travel albums of members of the royal family, Queen Victoria's daughters and daughters-in-law, who, as part of their royal duties, spent much time travelling abroad and chose to document their travels through photography, as well as the more established tradition of sketching. Although leisure is the main theme of the albums, there are occasional glimpses of work on the estates, and sometimes the women joined their husbands on overseas trips associated with their work or business interests – for example, Florence, Lady Harewood, visited the family estates in the West Indies with her husband. Although Lady Hawarden, perhaps one of the best known of Victorian women photographers, shares an aristocratic background with the other nineteenth-century women represented here, and though her landscape photographs originated in albums, she appears to have been more ambitious in terms of her photography, and sought a wider audience than immediate family and friends.

Family albums are essentially private documents that one is invited to peruse. It can feel intrusive to turn the pages of photographs assembled by an absent stranger. There is no one there to fill the gaps between the pictures, enlarge upon the captions, relate what happened during the moments either side of the snapped fraction of a second. Quite often the photographer is absent from the photographs that she has selected, ordered and captioned, although she might appear as a fleeting shadow cast on the ground in front of her subject.

Queen Victoria and Prince Albert had, as early as 1853, demonstrated an interest in photography by becoming patrons of the Royal Society of Photography. They collected photographs from all over the world, commissioned photographers to document every campaign in which British troops took part, to record life at Balmoral, to photograph their children, and then put these images together in bound albums. The queen was said to be a proficient photographer herself, and encouraged her daughters and daughters-in-law to take their photography seriously, sending them for lessons

at the London Stereoscopic School of Photography. The royal interest in photography must surely have influenced the wider public, and convinced many a husband or father that their wives and daughters might indulge in this pastime.

Given its royal patronage, fashionable ladies might well have attended public exhibitions mounted by the Royal Photographic Society[3], and thus been aware of developments in landscape photography, from Fenton's landscapes in the 1850s and 60s to Frederick Evans' studies of cathedrals in the exhibition of 1890, or his one-man exhibition of 1900. They might have subscribed to photography magazines or read theorists, for example, Emerson's *Naturalistic Photography* of 1889. But whereas we might detect influences from contemporary 'public' photography in terms of subject matter, or a picturesque approach to composition, to speculate on such influences in the absence of documentary evidence is to ignore the essential characteristics of these album images.

The album photographers would not have considered themselves in any way professional – they were ladies, and their photography a hobby on a par with 'botanizing', sketching, embroidery, playing the piano and singing. But more than displaying an accomplishment, the albums perform a similar role to that of the diary or the letter to a confidante, they provide a means of chronicling events. Whatever status might now be given to the album images, there is no doubt that for the most part this was intended as snapshot photography for private consumption.

In her essay on Vanessa Bell's photography, Val Williams suggests that we might begin to reassess snapshot photography, viewing it as a form of documentary photography. 'Removed from its traditional base of innocent revelation and placed instead with a concept of documentary order, precise in intention if sometimes eccentric in

FIGURE 1 Lucy Bridgeman: page from album c. 1856
One of Lucy Bridgeman's favourite backgrounds, the grand doorway to Castle Bromwich, the dower house at Weston Park. A sense of fun is shown in the posing of her subjects – Mr. Whitmore strikes a dandyish attitude, while the ladies appear more modest as they arrange themselves on a flight of steps.

execution, its preoccupation with the family and with the passage of time would allow its role as a marker and a recorder to be registered.'[4] Vanessa Bell's photographs are somewhat later than most of those appearing here, and they are mainly of people, but the point Williams makes is equally valid for these earlier landscape images.

Whereas sketch books of aristocratic ladies featured landscape scenes, in early photograph albums the focus is on people. The facility of the medium for translating reality was seen as its greatest asset, and family members and the domestic setting formed the subject matter. Another point made by Val Williams in *Women Photographers the Other Observers, 1900 to the Present* in 1986, where she is writing about Victorian women, is that 'photography gave these women the opportunity both to identify a personal history of their own families and to place those families precisely within a certain schema. A family, once photographed, assumes a particular reality, fixed in time by its portrayer, solid against a portico or balustrade, its class and its preoccupations firmly established.'[5] In addition to providing the women with a means of expressing their identity, the albums also allowed them to tell stories, and to comment, often humorously, on their society. Kate E. Gough, for example, whose album is held by the Victoria and Albert Museum, makes a wry comment on Darwinism by inserting family portraits into a sketch of a group of monkeys in a tree, and later putting photos of women's faces onto painted bosomy ducks swimming among reeds.[6]

IN AND AROUND THE HOME

Lucy Bridgeman (1826-58) was a young woman with time and money to spare. Her albums consist mainly of portraits, often made out-of-doors as she needed the bright light for

FIGURE 2 Lucy Bridgeman: page from album, c. 1856

A page recording visits to other country houses,
where large groups would have gathered for house parties.

FIGURE 4 Clementina, Lady Hawarden: Clementina seated on rock beside water.

© V. & A. Picture Library

Lady Hawarden's daughter, Clementina, is seated, holding a sketchbook, on rocks at the edge of the water; lost in thought, she gazes
at her reflection, and that of the scene behind her where the sheer limestone cliffs, crumbling walls of a building and ivy-covered
leafless trees remind the viewer that nature will reclaim her territory in time. It is worth noting that this photograph is stereoscopic,
and the drama of the landscape would be enhanced when rendered in 3-D

FIGURE 3: Clementina, Lady Hawarden: Isabella Grace,
standing in a roadway in woods.

© V. & A. Picture Library

the relatively long exposures. A cloth was draped over a wall as backdrop, and the same props of table and chairs appear page after page, the use of these indoor pieces of furniture making it clear that the outdoors is only used as expediency requires.

Nowhere in Lucy's albums does the landscape appear as subject matter – it is only present as background, and then it is very much the built environment rather than a natural one. It is attractive to speculate on the direction in which Lucy Bridgeman's photography might have developed. (Sadly she and her sister were burnt to death. They were reading by the fire when a spark set Lucy's dress on fire. In an attempt to save her sister, Charlotte's dress also caught fire and the two young women died from their injuries within a few days of each other).

Lucy's photography was about people; it was made in the privacy of her home, and Charlotte arranged the photographs in albums. However, at this time there were some women of her class taking photographs of the landscape as such and showing the pictures beyond their immediate social circle. Three sisters were members of the Photographic Exchange Club.[7] Members sent in two prints for each "exchange album". The subject matter was to be phenomena in nature and picturesque views of rural scenes, and antiquities (family photography was not allowed). A landscape photograph by Lady Augusta Mostyn from the Exchange Club Album of 1857 shows a rural scene with suitably picturesque features. A vast oak, leafless, its split trunk bound by a thick metal belt fills the picture surface; low sun illuminates its rough bark and the scars of fallen limbs. Flowing across the scene, and disappearing behind the tree is a slowly moving stream. Dwarfed by the mighty oak, a man and woman rest by its trunk. The man stands casually facing the camera, wearing a hat, carrying a stick, his back is against a rustic fence; next to

him sits a woman, in profile, facing the man and leaning on the fence. The symbolism of ancient oak, and the flowing stream is commonplace, the presence of the man and woman (blighted lovers?) adds the potential for narrative to the enjoyment of the photograph. This is as constructed as any of H.P. Robinson's 'Merry Tales' of twenty-five years later. However, Lady Caroline Nevill, Augusta's sister, who also contributed to photographic exchanges, compiled an album of about a hundred prints which are mainly family portraits, the landscapes forming a very small proportion of the photographs.

Private, family albums rarely show such purely picturesque scenes. Lady Hawarden (1822-65) photographed her husband's estate at Dundrum in Ireland, and while her landscape work reveals a picturesque sensibility, it also demonstrates a practical interest in documenting the day-to-day life on the estate: there is a sequence of thirteen photographs concerned with the felling of a tree and its aftermath. The order of the appearance of these photographs in the album is not known for certain, but we may surmise that they followed a sequence describing the event.

Rarely do we see the extent of the estate – there are few photographs that take in wide sweeps of land. Most images are of a more intimate, close-up view, where one is invited to look into the space, to travel through it to the dark wood beyond, or the glade of dappled shade (Figures 3). These are 'occluded' views.[8] Sensitive to the sensual aspects of the landscape, she focused on details – light falling through leaves, the delicacy of grass, the roughness of tree trunks in low-angled light, the enchantment of water.

The theatricality of Lady Hawarden's photography, exemplified in her studies from life, where her daughters, in fancy dress, pose indoors, is also apparent in the less controllable space of outdoors. The potential for a story to

unfold is suggested through the paths to be followed, doors and gates that stand ajar, light falling on ground just beyond our immediate view. Here nature dominates the frame – trees fill the sky and overshadow the human figures; but this nature does not arouse a frisson of delightful fear as the child walks into the dark wood: this is nature in a garden, tamed by man, where a little girl can wander safely. It is a domestic space.

Just five hundred yards from the house a disused and flooded quarry provided the setting for studies with a sense of mysteriousness and a strong picturesque appeal (Figure 4).

Some sixty years later Alex Dowdeswell began photographing her home and the surrounding land. Her albums are firmly fixed in the everyday life of rural England and range from 1919 to her death in 1985. Her subject matter is mainly the people and landscape of Wick Court, in Gloucestershire, the farm where she lived and worked through two wars and well into recent memory. The family bought the rambling and dilapidated house in 1919 and she began photographing at that time. Eccentric and reclusive, the Dowdeswells were often innovative in their farming methods; they were far from rich and privileged, but they indulged in one extravagance – a series of expensive motors which were also lovingly photographed. The photographs are rarely captioned, so dates, events and people are not known for certain. This might indicate a lack of interest for Alex in telling the family story (she and her sister remained unmarried) or it might be that her main interests were the farming and the land, changes marked by season rather than a linear progression through the years.

Features of the landscape around Wick Court are photographed time and again over the years, and in different seasons – an ancient pollarded oak, a herd of Gloucester cows grazing in its shade, the pear orchard in spring, sheep gathered

beneath the trees, like a Samuel Palmer painting. Annual events, ploughing and harvest are recorded, as are special occasions – a fence decorated with a row of at least thirty dead rabbits, the trophies of a shoot; the farmyard in winter when turkeys, geese and ducks (living at this point) parade in the snow. Other photographs display an interest in the landscape for its own sake – reflections of trees and reeds in still water, the simple line of a tree-lined track that leads to the house (Figure 5).

HOME AND ABROAD

Florence, Lady Harewood (1859-1943) started using a camera in the 1880s. By this time photography had become a relatively simple and relaxed procedure, far easier than it had been for Lucy Bridgeman or Clementina, Lady Hawarden. She used a light, hand-held Kodak camera. Its lens gave a wide angle, which made a viewfinder unnecessary, but it meant that there was poor definition at the edges of the frame, so a circular mask was fitted to the camera, hence the shape of the prints (Figure 6).[9] The Kodak allowed for greater spontaneity and intimacy, and many of Florence's snaps of family life reveal the Victorian upper classes at play – dressing up, playing organized games such as hockey, tennis and cricket, visiting friends, taking outings to local beauty spots, picnicking. As with Lucy Bridgeman, landscape at this point in Florence's photography provides the backdrop to human activity, and most usually it is the landscape of her home in Yorkshire, Harewood House. This was a privately owned landscape, created by the highly fashionable garden designer, Capability Brown, in the late eighteenth century. It was idealized, separated from the surrounding countryside, 'natural' looking, but tamed and controlled, still the domestic sphere.

Florence was a Bridgeman (Lucy Bridgeman was her

FIGURE 5 Alex Dowdeswell: Wick Court, Gloucestershire.

A typical page from Alex Dowdeswell's album – haymaking, the house, the dairy herd. The hayrick tops are there, one suspects, purely for the pleasure of the image.

aunt, although Lucy died before Florence was born) and it might well be that she was inspired to take up photography by looking through Lucy's albums at Weston, with her sister, Mabel, also a keen photographer. But this is to surmize.

The landscapes in which these portraits are taken are empty of people other than the participants in the events. There are very few photographs in the albums before the early 1900s that are taken in more public areas, other than historical sites and buildings.

Visits to ruined abbeys and castles offered suitably picturesque subjects for photography. Harewood had its own ruined castle, which Turner had painted a hundred years before, but the castle rarely appears in the albums, which suggests that Florence was not so much interested in exploring the picturesque potential of the landscape as recording family occasions (Figure 7). The inclusion of the three photographs of people (each person carefully identified) on this page reinforces the focus of her photography as being about documenting family life. It is only when Florence travelled abroad that she began to take photographs of street scenes, and of people other than her immediate family in the landscape (Figures 8 & 9).

The family owned plantations in the West Indies. A tour of the islands and of their property took place in 1906. The landscape becomes the subject matter of many of the photographs from this trip, shots taken either of or from properties owned by the Earl of Harewood. Florence uses a Kodak panoramic camera with confidence to photograph the shapes of the islands from the yacht, and when used on land it gives extent to the landscape.

A range of hills provides the subject of the top picture on the page of photographs of Barbados: a group of huts gives human interest and scale, but is both literally and metaphorically peripheral to the image. One cannot imagine

FIGURE 6 Lady Harewood: White Stitch, 1896

A day out with her sister and brother-in-law at their family home. Mabel is caught unawares as she prepares to take a photograph of the landscape (her husband Willie pointing out something of interest with his stick).

FIGURE 7 Lady Harewood: album page dated 1897-1900

A page from a later and larger album. The format of the album has allowed her greater freedom to arrange the photographs according to both subject matter and their visual qualities.

FIGURE 8 Lady Harewood: Barbados, 1906

FIGURE 10 Attributed to Mary, Duchess of York: Rumpenheim, 1896

The Royal Archives © Her Majesty the Queen

A line of rowing boats is strung across a lake in a highly formalized composition – the diagonals of boats and ropes balanced by three trees and a building reflected in the water, with the distant shoreline providing a horizontal counterpoint to the criss-cross of the delicately drawn lines of the boats. This photograph is balanced by an equally formally composed image of a ferry crossing a river, with the accent here on the play between horizontals and verticals.

FIGURE 9 Lady Harewood: Jamaica 1906

The last page of photographs of the West Indies trip shows Jamaica photographed mainly from a train rushing through the landscape. Again, the design of the page has been carefully considered; there is no human interest, just the passing scenery and a strong sense of movement – surf crashing on the shore, wind in the trees – a tourist's view.

Florence taking snaps on the streets of London or of Leeds, but abroad she clearly feels comfortable about it, although a certain diffidence is evident in the generous space she allows between the photographer and other people in the street scene of the bottom right photograph. The central photograph of the page shows Florence standing with her back to the camera, next to her husband, Henry. Her own camera lies on the ground behind her. This photograph offers a glimpse of a time and a place so distant that it is not possible to unravel what is going on. All eyes are focused on a man standing in the centre of the image, who appears to be holding a pan or dish – perhaps molasses produced on the plantation? One woman looks towards the camera, connecting us to the scene being enacted, while bent trees and the line of a building behind frame the event. The photograph was probably taken by Bill Lascelles, a cousin of the earl's, who managed the estates in Barbados. Whatever the occasion, Florence clearly thought it sufficiently important to include with her own photographs of Barbados.

Books of photographs of travels had long been popular (Francis Frith, John Thomson, Felice Beato). English aristocrats such as the Harewoods would hardly have seen themselves as travellers in exotic lands when visiting their properties in the West Indies, however the tradition of photographing foreign scenes would have legitimized such candid shots.

Photographs taken at Harewood and other locations at home that appear in Florence's albums concentrate on people and activities. If one thinks of how albums are used within the family – memories are shared or family stories told from one generation to the next – then there is no obvious need to record the landscape, it tends to stay the same, and the viewers of the album know it well. But the interior of houses change and, again, the interest of the lady of the house in such changes is reflected in the photographs Florence took of 'my sitting-room' or 'the library at Harewood' or 'my bedroom'. The pages of

photographs from the West Indies, though, document places and a way of life literally foreign to those who have not visited – aunts, cousins, grandchildren. The record of 'our properties the other side of the world' (my words) is made and presented for those who were not there. In many of the pages Florence includes at least one photograph of herself, with people who are connected with the work or the place. Again, this gives a different emphasis to the images. This is not playing in the back garden (or estate) but a serious attempt to document a visit. These landscape images might now be read as an expression of colonial arrogance, rather than objective documentation; they might appear to celebrate ownership, wealth and power. But if we decide to give them this reading, it is important to bear in mind that they were intended for private not public consumption, and that the social relations suggested by the images were very much taken for granted at the time.

ON TOUR

The Royal Collection includes hundreds of albums, and just a few have been chosen to illustrate the kind of landscape photographs that female members of the royal family were taking, mainly on overseas visits. Many of the photographs are taken from on board ship or at private social events such as picnics, as much of the time when they were not actually travelling would have been spent on official engagements.

Mary, Duchess of York (1867-1953), the future Queen Mary, put together an album which she called 'Kodaks – partly done by me, 1896'. Once again, photographs of people in places outweigh those of landscapes *per se*. Just a few pages consist solely of landscapes (Figure 10).

In contrast to the reflective mood created by the still waters of Rumpenheim, there is in the following pages an abrupt change in the way in which the pictures are presented.

Corners are cut off the photographs and they are overlapped, crowded onto the page, stuck at angles to one another. At Mentana, for example, the dizzying height of the mountains is exaggerated by this kind of presentation.

Princess Victoria of Wales 1863-1935, was a keen photographer who delighted in the landscape. Her album of 1901-1905 demonstrates her skill in using a panoramic camera. Her landscape studies range geographically from Norfolk to Norway. Cromer, on the coast not far from the royal residence of Sandringham, provides ideal subject matter for the panoramic camera which sweeps over a landscape in which figures are tiny, insignificant against the open sky and sea; on the Norfolk Broads reeds edge the frame, while a square-rigged boat dominates the low skyline, and details of the boat from which the photographer takes her view give a sense of immediacy and engagement with the scene. In Norway she uses the same techniques of framing and focus, concentrating at times on details of wavy grass and sparkling waves that comprise the shoreline, or on board ship in the fjords creating a sense of drama from contrasts of light and shade, of movement arrested, fully exploiting the photographic qualities of a seemingly empty landscape.

This perfect stillness and harmony contrasts with pages where there is an abrupt change in rhythm, the photographs jostling for space, pasted in at odd angles. This is just what Queen Mary had done in her album of 1896 – perhaps they had been looking at earlier albums together ...

STORIES IN PICTURES

Queen Alexandra (1844-1925) was born in Denmark, came to England to be the wife of Edward VII, and spent much of her time at Sandringham in Norfolk. In this album of August to September 1908 she uses text and the arrangement of the

FIGURE 11 Princess Victoria of Wales: sea views of the fjords at Langbigner, c. 1905

The Royal Archives © Her Majesty the Queen

An image of almost Classical balance and harmony: the distant skyline cuts across the image at the Golden Section. The frame is divided
vertically by the edge of a boat and four ropes at one side and a man leaning over the side at the other. A sailing boat and a small rowing boat,
perfectly reflected in the mirror of the water, provide the central focus.

FIGURE 12

Queen Alexandra: 'Our boats taking us off after our picnic', at the fjord at Christiania, 1908

The Royal Archives © Her Majesty the Queen

The use of a panoramic camera for the scenes of the picnic give an almost cinematic quality to the work –
we follow the figures into the scene, and movement is arrested, but only for a fraction of a second.

FIGURE 13 Queen Alexandra: Scandinavia, 1908

The Royal Archives © Her Majesty the Queen

There is no caption to this last page of the album. Perhaps for Alexandra it captures the essence of a
Scandinavian landscape. Rowing boats float across the water, marsh grasses are reflected in the glassy surface,
while a stormy sky threatens disturbance to the stillness and quiet of the scene, and etched against the flat
surface of the water we see figures crossing a delicate wooden bridge and below it a barbed-wire-covered gate
is photographed straight on, arresting progress to the flat water beyond.

images to tell her story. The album opens in England, and the first page is titled 'My little house by the sea'. The personal pronoun underlines the diary-like nature of the album. She then travels back to her home in Denmark, individual images and pages annotated in detail: '24th August, we arrive at Dresden on our way to Norway. We walk in procession to our coach. We start in our launch.'

Narrative is central to this album and this trip was evidently emotionally significant for her. 'The arrival of my sister on the Polar Star, Aug 31, 1908' is carefully documented as is her departure a week later.

After a page of three panoramic photographs titled 'The Polar Star leaves with my sister, September 7th 1908', the central photograph of which shows a woman leaning over the rail, camera in hand, looking at the departing ship, the remaining pages of photos from this part of the trip are heavily annotated, the words squashed between the pictures: 'In the morning went to Bygdo to take leave of poor Maud who was ill in bed after all the five balls receiving where she collapsed'; 'Also said goodbye to sweet Olaf' (her little nephew); 'Last view of Charles and Victoria' (Princess Victoria) shows a tiny boat in a vast sea.

At times Queen Alexandra takes her landscape photography in a direction which is far from documentary, and in its formal qualities appears remarkably modern. 'Sea rocks near Bygdo' shows an apparently empty shoreline, nothing but the sea and the flat rocks; the eye is drawn to details — flinty pebbles, grasses bending in the wind, and the spray dancing on the waves as they break over the rocks. Sometimes the title offers more than the photograph. 'Sunset on our way home' is a minimal white tear across a grey sky and a line of silvery ripples reaching down toward the viewer. These landscapes, with their captions, act very much as personal *aide-mémoires* — in taking the photograph the

chronicler is creating the memory, illustrating the story.

These last photographs are highly personal and, I would suggest, are about identity and a sense of home, and yet they have moved away from the domestic space, which in a way was a fantasy world, that of 'my little house by the sea'.

CONCLUSIONS

In contrast to the contemporary women photographers whose work this book examines, the Victorian and Edwardian women photographers would not have described themselves either as artists or photographers (apart from Lady Hawarden). Photography for them was a means of recording aspects of their lives, in a similar way to that employed today by most of us — in family and holiday snaps, or perhaps more commonly now, on video tape. Pasting photographs in an album, captioning them, or not, is a way of completing the process of photography. It frames the images, giving them a structure in which to be viewed or read. The whole album, or page, is more than the sum of its parts.

While I have focused on landscape images in order to try to assess the position that these photographs might take within the development of women's landscape photography, in most cases it is not possible to view them solely, or merely, as representations of the landscape. The landscape, more often than not, is a backdrop against which personal stories are told, or it is an extension of the domestic space. This is particularly the case when the photographs are taken at home (as opposed to 'abroad'), whether we are looking at Lady Hawarden's photographs at Dundrum, or Alex Dowdeswell's at Wick Court. However, it is significant that the work of these two women is separated by time (60 years), by class and by their relationship with the land. Lady Hawarden made visits with her family to the estate in Ireland, but Dundrum

was not their permanent home, and although her series of studies of the estate workers indicates an interest in the work of the estate, the primary concern is aesthetic — the fall of light through a window illuminating the carpenter at his bench, an apparently conscious quoting of Vermeer or de Hooch. Alex Dowdeswell's relationship with the land was based on a more practical understanding of farming, and that the repeated photographing of particular features in the landscape may reflect an emotional attachment to the land, a feeling of belonging.

Lady Hawarden occupies a somewhat different position than the other photographers. She regarded herself seriously as a photographer, exhibiting with the Photographic Society of London. Her work was recognized by the photographic press during her lifetime, and an exhibition at the Victoria and Albert Museum in 1999 reinforced her status as an important figure in nineteenth-century photography. Her work has greater aesthetic appeal than most of the other photographs shown here, but the women share sufficient common ground for us to discern an emerging role for this 'domestic' photography.

I am suggesting that the use of photography in the construction of albums is an extension of the way in which women recorded their lives in diaries; and in the case of educated ladies, they had, since the eighteenth century, documented their surroundings and travels in drawings and watercolours that were then arranged in albums. The early photograph albums can be seen as laying down the conventions of the family album that we still employ today — focusing on family life, high days and holidays. In their depictions of the landscape the photographers tend to use the established aesthetic of the picturesque. Rarely do the photographs here stand alone; they need to be seen in context, both of the social position of the women who made

them, the historical moments they inhabit, and literally of the albums in which they have been pasted. As part of a constructed chronicle they also benefit from being seen in sequence. They provide us with an insight into the women's private lives and offer critiques of how they perceived their worlds, providing valuable commentaries on the times and places they describe.

ENDNOTES

1 James Mudd, in a lecture to the Manchester Photographic Society in 1858, quoted in Seiberling, Grace, *Amateurs, Photography and the mid-Victorian Imagination* (Chicago: University of Chicago Press, 1986).

2 Lady Eastlake was the wife of Sir Charles Eastlake, Director of the National Gallery of Art and President of the Photographic Society of London. Her writings on photography are among the first to describe a history of photography and to engage with the issues of photography's position within the visual arts.

3 Queen Victoria wrote in her diary about such a visit, where she was attended by Roger Fenton: 'There are three rooms full of the most beautiful specimens, some from France and Germany, and many by amateurs. Mr. Fenton explained everything, and there were many beautiful photographs by him ... Some of the landscapes were exquisite, and many admirable portraits.'

4 Extract from the essay, 'Carefully Creating an Idyll' from Spence, Jo, and Holland, Patricia, (eds) *Family Snaps: the Meanings of Domestic Photography* (London: Virago Press, 1991) p 186.

5 Williams, Val, *Women Photographers – the Other Observers 1900 to the Present* (London: Virago Press, 1986) p 15.

6 See Haworth-Booth, Mark, *Photography: An Independent Art – Photographs from the Victoria and Albert Museum 1839-1996* (V. & A. Publications, 1997).

7 See Seiberling, *Amateurs, Photography and the mid-Victorian Imagination*.

8 See John Barrell's essay, 'The public prospect and the private view: the politics of taste in 18th-century Britain' for a discussion on eighteenth- and early nineteenth-century approaches to landscape, and the view that the man of taste (and of political authority) was capable of generalizing and appreciating the panoramic view whereas the uneducated, the vulgar and women, were only capable of the narrow, occluded view, and the representations of accidents of nature.

9 To take a picture you turned the key to advance the film, pulled a cord to tension the shutter and pressed the button to make an exposure. Then the entire camera was sent away to have the film processed. The film was unloaded at the factory, a new film inserted in the camera and the next 100 exposures could be made.

A Conditional Presence:
Women Landscape Photographers in Europe

John Stathatos

To consider the work of women within the field of landscape photography begs a question about the purpose of considering such work in isolation from the genre as a whole, since it is obvious that the study of any human activity in the light of factors extraneous to that activity itself – factors such as sex, race, nationality or religion – is meaningless if approached prescriptively. An investigation of, for instance, the work of francophone African film-makers or male heterosexual Scottish painters will very likely lead to the discovery of a number of traits common to each group; if, however, these traits are subsequently held to be intrinsically African, Scottish or heterosexual, in such a way as to attribute the nature of the work examined to supposedly inherent and immutable characteristics, the entire process becomes intellectually and politically suspect. Such investigations, on the other hand, are analytically valuable, helping to explain why and under what influences or pressures the activities of a particular group developed in a particular way at a particular time.

If research into aspects of women's photographic representation of landscape throws up any one significant fact, it is the relative rarity – seen against the whole sweep of photographic history – of such representation, and some of the far from insignificant practical reasons for this are discussed below. There is, howe···· more general consideration which bears examination, which might be called the conditional nature of women's presence within the landscape. Except in the case of nomadic or hunting and gathering cultures, women have traditionally been excluded from the physical experience of landscape and from participation in its working and shaping. Women have not by and large owned land; they have usually been restricted to work in and around the domestic sphere; and under normal circumstances they have been discouraged from travelling any great distance from home, and then always under the protection of their male family members. In other words, in most periods and societies, whenever women have ventured into the landscape, they have in effect been there on sufferance.

This conditionality appears even more marked where the intellectual and emotional shaping of landscape is concerned. In one of the most complex examples we know of, that of Aboriginal creation myths, the processes through which landscape is assimilated to narrative structure, and in particular the ritual songline journeyings, have always been a specifically masculine activity. Inevitably, physical and intellectual exclusion from the landscape has entailed an imaginative withdrawal: landscape and its appreciation, for instance, are largely absent from women's writing, particularly prior to the twentieth century. As far as contemporary photographic practitioners are concerned, there is a clear realization that not only is landscape not a natural given, but that it is a cultural construct in whose construction women have not participated.[1]

To begin with then, some unavoidably raw data. The single largest international photographic database currently available to researchers is probably Michel & Michèle Auer's CD-ROM *Photographers Encyclopaedia International* (1997).[2]

This includes entries of various length and quality on a total of 6,515 photographers. European photographers, excluding Britain but including Russia, come to a total of 3,862, of whom 435 are women – a ratio of roughly 8:1. If search criteria are refined to include landscape among the genres or themes pursued, we end up with a final count of 170 continental women photographers whose output is said to have included at least some landscape work. It must of course be emphasized that these figures are far from complete, particularly where eastern Europe is concerned, and that the term 'landscape' has been interpreted very loosely by the compilers of the database.[3] Nevertheless, the results of such a search are not without value and offer some interesting pointers.

For one thing, women appear to have been almost entirely absent from the nineteenth-century landscape. Only 17 women of all nationalities are listed as being active in this area prior to 1900, most of them British; a mere four could be described as continental. One obvious reason must be the fact that given the size and weight of nineteenth-century photographic apparatus and, having regard to the impracticalities of feminine attire at the time, few women would have been inclined to wander across hill and dale in search of the picturesque. In view of the high cost of equipment and the financially dependent status of most women, economic considerations would have been equally decisive. Furthermore, as Liz Wells has pointed out, 'Other limitations also intervene. These include safety

considerations: it may be reckless for women to traipse around the country in remote open spaces on their own. Regardless of whether there is really any great risk involved, simply feeling insecure is in itself enough to limit what women undertake.'[4] Wells is here writing about the 1990s, but these considerations would have been even more relevant to the previous century. If further confirmation were needed, of the 124 nineteenth-century 'travel and regional photographers' listed by Witkin and London in their *Guide*, not one is a woman.[5]

Additional research only seems to confirm the paucity of early women landscape photographers. A useful source of information on early Portuguese photography, for instance, is the catalogue of *Provas Originais, 1858-1910*, a survey exhibition of 272 images drawn from the extensive municipal photographic archives of the city of Lisbon.[6] Of the 272, one only, the photograph of a mountainous landscape in the Caldas de Monchique, is credited to a woman, Rosalina F. Lima, and she proves to be the only photographer in the exhibition about whom nothing further is known, not even her place of residence.

The investigation of other national photographic histories proves equally unrewarding, and even the existence of a vigorous tradition of landscape photography does not seem to guarantee more than a token feminine presence, if that. Finland is another relatively small country whose early photographic history has been the object of intensive recent study. According to an apparently exhaustive survey of the subject published in 1992, 'The commercial and industrial reforms of the 1860s brought about a fundamental change in the structure of society. Although the road and rail network improved, few people still travelled further than the nearest market town. Photographs, therefore, offered the first authentic picture of Finland, concrete images on which

BRIGITTE BAUER: (from the series 'Roundabouts')

Chromogenic prints 50 cm x 50 cm

people could focus their national aspirations';[7] the large number of topographic and landscape images reproduced in this same survey include, however, only a single example by women, the sisters Anna and Maria Renfors who were active during the 1870s and 1880s.

In France, one could mention the little-known Jenny de Vasson (1872-1920), who began photographing around 1898. During the next 20 years, she accumulated a substantial body of work on rural France, including landscapes and portraits of country people, with particular emphasis on her native region of the Berry. She left some 5,000 negatives of all kinds and around 2,000 prints, though unfortunately many were destroyed by enemy action in 1943. Obviously talented and energetic, de Vasson also kept extensive journals and corresponded regularly with a number of scientists and artists, including the writer André Maurois.

A significant exception to the rule that few women were prepared to venture with cameras into the open countryside during the nineteenth and early twentieth centuries was that of women whose families or spouses actually owned, or were influential over, tracts of that same countryside. While little work has been done on the class origins and economic circumstances of early women photographers, logic suggests that since they were unlikely to be earning a living through their exertions, it would automatically be the economically better-off and higher status women who had access to the skills and equipment of photography. A recently rediscovered and extremely interesting such case is that of Mary Paraskeva (1882 – 1951), the daughter of an expatriate Greek millionaire raised on the vast country estate of Baranovka in the Crimea, who left a large number of glass stereoscopic lantern slides including some very sophisticated landscapes as well as many scenes of peasant and village life on the eve of the First World War.[8]

Others were simply extraordinarily tough and independent-minded women, like the Swiss photographer Ella Maillart (1903 – 1997) who took part in the 1924 Olympics, became a stunt girl in skiing films, visited the Soviet Union in 1930 and wrote a book about it, photographed Northern China in 1933 and travelled from Peking to the Himalayas across occupied Manchuria and the Taklamakan Desert in 1935.[9] Nevertheless, though their numbers increased slowly throughout the twentieth century, the great majority of women landscape photographers are contemporary.

This is not to imply that even today, women are represented within the genre in significant numbers; the influential catalogue of the 1995 exhibition *Paysages, lieux et non-lieux*, which examined contemporary European landscape photography in some detail, particularly from Italy, Catalonia, the Netherlands, Germany and Luxembourg, included the work of just two women.[10] Three years earlier, the 23rd edition of the *Rencontres Internationales de la Photographie* at Arles, also devoted to contemporary European work, did not include any women in its substantial landscape section. It is difficult to say to what extent these two cases are an accurate reflection of the number of women working on landscape in Europe, or of the quality of their work. Nevertheless, one might note the continuing male dominance of photographic institutions in a number of European countries, as well as the relative curatorial laziness in which the fossilization of such institutions is apt to result.

Looking at what can only be, at best, a representative sample of work from across Europe, is it possible to make any generalizations at all about the nature of landscape-based photographic work being produced by women today? Hedged about with all due reservations, it is I think possible to identify a couple of areas for which women have shown little or no enthusiasm and which have as a result become de

EVE KIILER:

'Estonian Art in the Age of Mechanical Reproduction', 1992

Mixed media installation: photomural and framed texts, 3 x 4.4 metres.

facto male preserves: one is the American new topographics movement, and the other is the German school of large-format landscape photography ultimately descended from the Bechers, with its emphasis on typology on the one hand and on monumentality and the sublime on the other. It seems safe to assume that when they turn to photographing landscape, women are not on the whole attracted to either emotionless or grandiloquent representations of the world around them.

It is true that some bodies of landscape work by women photographers may at first sight appear to fall under one or another of these categories, but in almost every case the resemblance turns out to be superficial. Heidi Specker (German, b. 1962), for instance, photographs Berlin office blocks and architectural complexes in an appropriately neutral style, but undermines the whole aesthetic by digitizing, blurring and otherwise degrading her images,

which end up looking like models, or architectural fantasies. The exhibited images are themselves digital inkjet prints, a further blow to the German landscape tradition which has usually insisted on large, carefully (and expensively) produced conventional prints.[11]

Brigitte Bauer (b. 1959), a German photographer living and working in France, has produced at least two major series of colour images which seem related to the aesthetics of Thomas Struth et. al.: 'Roundabouts' (ongoing from 1995), and 'The City and the Garden' (1999); in both cases, however, the apparently neutral point of view is subverted by irony and a tongue-in-cheek aestheticization which reveals itself to be a critique. Of 'Roundabouts', Bauer has written that 'these spaces are usually designed with considerable care and equal bad taste. Such attempts at adding aesthetic value, at beautifying essentially functional spaces, demonstrate a highly standardized treatment of nature in cities. This perverse aspect is something I try to show photographically: the image is intended at first sight to prettify, to appeal to the spectator, while the critical dimension reveals itself to anybody who lingers a little over the image.'[12] This critical approach to the representation of landscape connects Bauer to more overtly oppositional British photographers such as Miranda Walker and Ingrid Pollard, while like Pollard, she has consistently engaged with questions concerning the nature of landscape today; writing about a recent series of images of Mont Sainte-Victoire, she notes 'I had intended simply to photograph a mountain, and found myself serving an apprenticeship into the matters of landscape.'[13]

In 1992, the Estonian artist Eve Kiiler (b. 1960) launched a critique of her fellow-countrymen's unquestioning attitude to the platitudes of both art and nature with an installation entitled 'Estonian Art in the Age of Mechanical Reproduction'. This consisted of a 3 m x 4 m photomural of

NATASSA MARKIDOU: 'Untitled', 1993

Silver print and handwritten text, 32 x 96 cm

NATASSA MARKIDOU: 'Untitled', 1994

Silver print and handwritten text, 32 x 96 cm

a stream running through woodland produced by a firm called ScanDecor, on top of which were hung small framed texts with quotations from *A History of Estonian Painting*. The texts describe a picture by the locally famous landscape artist Konrad Mägi, substituting the name 'ScanDecor' for the artist's name throughout: 'Having returned to Estonia, ScanDecor became one of the first artists who consistently conveyed Estonian nature, endowing it with a definite artistic interpretation.' According to Kiiler, 'Visitors to the Tallinn Art Hall loved the landscape. They were sure they knew the precise place, which looked exactly like Lahemaa National Nature Park [the scene was in fact shot in England]. The visitors took snapshots of each other, posing in front of the mural as if at a famous tourist spot.'[14]

Also frequently encountered in contemporary practice are essentially metaphorical uses of what seem to be straightforward documentary renditions of landscape. The Greek photographer Erieta Attali (b. 1966) has consistently taken this approach, most notably with her photographs of the Anatolian highlands in 'First and Last Landscapes' (1996); here, the stark black and white images of parched and barren Turkish valleys become a symbolic *tabula rasa* in which the viewer may see either the beginning or the end of the world, 'a book waiting to be written in, or the silence after Armageddon'.[15] Though superficially dissimilar, the remarkably beautiful colour diptychs which the Finnish photographer Marjaana Kella (b. 1961) is currently working on in the Ticino – distant mountain panoramas tending to abstraction as they merge into banks of mist and cloud – are also about nothing as elementary as the transmission of topographical data.[16]

For many women photographers, landscape is not so much an impersonal set of data and conditions to be recorded as a context within which the photographer locates herself and of which she is an organic part. Natassa Markidou (b. Athens, 1965) considers her own presence within the landscape of defining importance and she undermines the traditional fixed point of view by moving about and subsequently abutting or overlapping related images, as well as by adding brief, hand-written texts which provide additional or alternative interpretations of the scenes depicted. The process is one whereby, in her own words, 'an inscribed, fragmentary narrative of impressions, colours, smells and sounds which complement the images, reminding the viewer once again of the significance of my presence in the space I photograph and of photography's inability to describe emotional responses to the place photographed.'[17]

Another Greek photographer who has experimented with composite and fragmented depictions of landscape is Eleni Maligoura (b. 1951), whose 'Journal' (1990-91) consists of six large composite images of beach scenes, the longest measuring more than two and a half metres. According to the photographer, 'Images are gathered during the course of a day and, after a selection process mediated by memory, are unified into a larger image which recapitulates sensation.'[18] Fragmented and repeated, these images are simultaneously a Proustian attempt at recreating the past and a literal representation of time passing. The waves breaking and receding, the footsteps in the sand, the ephemeral marks of wind and water, photographed sectionally but presented synthetically, underline the rarely noted fact that landscape is a dynamic rather than a static phenomenon.

This resolutely subjective experience of landscape is something one comes across time and again in the work of women, almost always closely associated with the processes of memory. Corinne Mercadier (French, b. 1955), for instance, has produced a series of mysterious sepia-coloured Polaroids of an unidentified waterfront, prints which Yves Abrioux has called 'the after-image of distant days'. Whilst these images correspond to none of the conventional aesthetic depictions of landscape, and though the topographical information to be garnered from them is once again less than useless, they nevertheless carry powerful intimations of a subjective response to a particular location. For Abrioux, 'These works are untitled, their location some unspecified backwater. They do not, however, show the "margins of progress", but rather the fringes of an unidentified subject's biography. Mercadier's photographs are almost like memories of holiday snaps; they are the after-image of distant days, which emerge not so much as landmarks but as indistinct forms, or perhaps a particular quality of colour ... It is as if, from the workings of a memory almost erased by the blank wash of water and sky, all that could be saved were a few such patches of visual intensity.'[19]

Finally, and very briefly, I should like to touch upon another category of response to the landscape by women photographers which is perhaps less immediately obvious: that of the depiction of rural ceremonies, rites and folk customs. This particularly rich field has of course been mined by men as well as women, but it is one in which women have been particularly active; they include, to take only a few examples, Markèta Luskacová's 'Pilgrims' series from Slovakia (1967-74), Marialba Russo's images of religious rituals in southern Italy, Christina Garcia Rodero's 'España Oculta' (1989) and subsequent work, as well as the work of Marianna Yampolsky in Mexico during the sixties and seventies. One reason for the success of women in this particular genre may be the fact that they can have relatively greater access than men to a number of situations. In some cases, there may also be an emphasis on the sexual and quasi-hysterical aspects of folk customs in largely Catholic societies; as an Italian critic has pointed out in connection with Russo's

work, 'Some of her most successful photographs – such as those of men entangled in thorns, documents of mass self-flagellation, pictures of black-cloaked, thorn-crowned women – reflect on popular religious festivals as announcements of sexual repression. One of the most striking photographs taken during this period portrays a ritualistic enactment – by men – of the throes of labour, testifying to an ancient awe and fear of matriarchy.'[20]

Clearly, despite the absence of a strong tradition upon which to build, contemporary European women photographers are increasingly addressing issues of landscape, often finding new and original ways of approaching the subject. Some of these approaches have already been cogently summarized by Susan Butler in *Shifting Focus*; they include 'the sense of a speculative, imaginative quality within critical observation, the evocation of subjective experience, the apprehension of connections between vision and the other senses and an embracing of viewpoints suppressed or insufficiently acknowledged in contemporary culture'.[21] It is through the application of these and similar strategies that women, and European women in particular, have begun a process of reclamation of landscape.

ENDNOTES

1 I am grateful to Susan Trangmar for suggesting the term 'conditional' in this context, and for discussing the implications with me. Trangmar's own photographic sequence *Untitled Landscapes* (1986) touches eloquently upon some of these themes.

2 Auer, Michel & Michèle, *Photographers Encyclopaedia International* (Neuchatel: Editions Ides et Calendes, 1997).

3 One source of geographical distortion is the huge preponderance in the database of French and Swiss photographers (respectively 21% and 7.6% of the total), not surprising in a Franco-Swiss co-production.

Interestingly, while with the exception of a few peripheral regions for which no women photographers at all are listed (Bulgaria, Slovenia, Slovakia and Croatia), the proportion of men to women in most European countries is relatively stable at around 10:1, Sweden displays the greatest disparity, with only two women listed as against 58 men.

4 Wells, Liz, *Viewfindings: Women Photographers, 'Landscape' and Environment* (Tiverton: Available Light, 1994) p 5.

5 Witkin, Lee D. and London, Barbara, *The Photograph Collector's Guide* (Boston: New York Graphic Society, 1980).

6 *Provas Originais, 1858-1910* Arquivo Fotográfico, Câmara Municipal de Lisboa, Lisbon, 1993.

7 *Valokuvan taide: Suomalainen valokuva 1842-1992* [Finnish photography, 1842-1992], Helsinki, 1992, p 465.

8 The work of Mary Paraskeva and of her close friend Argine Salvago (1883-1972) was first brought to light by Maria Karavia in her book *Odissos, i lismonimeni patrida* [Odessa, the forgotten homeland], (Athens: Agra Editions, 1998). See also Stathatos, John, 'Pioneers of national pride', *Times Literary Supplement*, London, 16 July 1999, pp 18-19.

9 She was accompanied on this last occasion by the British explorer and journalist Peter Fleming, who wrote admiringly that 'she had courage and enterprise and resource; in endurance she excelled most men ... She could eat anything and sleep anywhere' (*News from Tartary*, London: Jonathan Cape, 1936, p 26).

10 *Paysages, lieux et non-lieux: le paysage dans la photographie européene contemporaine*, (Luxembourg: Café-Crème, 1995).

11 See *European Photography* 60, Göttingen, Fall/Winter 1996.

12 Brigitte Bauer, written communication to the author, 5 March 2000.

13 Bauer, Brigitte, 'La montagne des tableaux des paysages', text to accompany the exhibition *Montagne de la Sainte-Victoire*, Galerie Polaris, Paris, May 1999.

14 Eve Kiiler, written communication to the author, 22 February 2000.

15 See Stathatos, John, (ed.) *Myth and Landscape*, (Athens: European Cultural Centre of Delphi,) 1996.

16 My thanks to Caryn Faure Walker for sharing her research on contemporary Finnish photography.

17 Natassa Markidou, written communication to the author, 5 March 2000.

18 Maligoura, Eleni, text published in *Photoarchive 1975-97: Contemporary Greek Photography* Vol A, CD-ROM, (Athens: Photography Centre of Athens, 1997).

19 Maligoura, Eleni, text published in *Photoarchive 1975-97: Contemporary Greek Photography*.

20 Russo, Antonella, 'The invention of southernness', *Aperture 132: Immagini Italiane*, New York, Summer 1993, p 62.

21 Butler, Susan, *Shifting Focus* (Bristol and London: Arnolfini & Serpentine Galleries, 1989), p 42.

KATE MELLOR

In the Steps of Robert Pinnacle

This work was
made for a commission
to document European spa towns.
I chose to base the project upon the career
of the landscape painter Robert Pinnacle, who visited
and resided amongst these unique societies which provided his main
source of patronage. In Pinnacle's era, artists frequently used such devices
as pinholes to assist perspective and, partly for this reason, I chose to re-construct his
works using a pinhole camera. While re-tracing his career through Europe
I made other photographic works using a variety of formats and
processes, both contemporary and historic, drawing on
the narratives that prevail in these once
fashionable locations.

XIXᵉ SIECLE

GÉNÉRAL JARDON.
MADAME RECAMIER.
BARRAS.
VOLNEY.
DE JOUY.
MONGE.
DE CANDOLLE.
REINE HORTENSE.
NAPOLÉON III.
PRINCESSE LAETITIA BONAPARTE.
TALMA.
REINE DE WESTPHALIE.

PRINCESSE PAULINE BORGHÈSE.
SOUTHEY.
GUILLAUME D'ORANGE
ROBERT PINNACLE.
BENJAMIN CONSTANT.
GUILLAUME Iᴱᴿ ROI DES PAYS-BAS.
TSAR ALEXANDRE Iᴱᴿ.
DUC DE WELLINGTON.
FREDERIC - GUILLAUME III
ROI DE PRUSSE.
OMMEGANCK.
NICOLAS Iᴱᴿ
TSAR DE RUSSIE.

Extract from Robert Pinnacle's journals –

.. I am glad to say that I am acquiring some Italian, though it will never be a match for my French. My facility for language stands me in good stead with much of the society hereabouts and I have found a good friend in Alphonse (thought to be the poet Lamartine) who has introduced me to roulette – a game invented at this very casino, conveniently next to his dwelling. It consists of a wheel of turning numbers into which a ball is dropped to bounce where it will, settling finally on an apparently random figure. I have quite a fascination for watching this curious action and have sometimes experienced the strange sensation of knowing when it will land on my number...

...Met Mme — her drawings were most finely-detailed and of admirable precision, yet executed with much esprit. They were, undoubtedly, among the most beautifully proportioned prospects that I had seen. I asked with whom she had studied, and received the reply that as a young girl she would roam all over the house, even to the attics, and peer from the upper windows to the countryside below. The intersection of the window frames had assisted her grasp of perspective. This had been her guiding inspiration. These childhood drawings were much encouraged by her governess whom I gathered had some artistic connection.

Some of her early drawings she had made into fans, which she uses, signalling to me across the salle. I often examine these and always notice yet another nuance which has escaped my first perusal. The work's finest quality is that the feeling of space and light goes beyond feature, powerfully affecting the senses...

...I see her make her way between the baths and the chapel. Each day she seems a little more frail. She no longer dances. She takes her sedan chair. Sometimes I pay a call to be trounced at cards but today she was too fatigued to entertain callers.

At chapel this morning I saw her bewildered face in the shadows. She prays to a god who appears not to heed her suffering. She is the best of people...

...On reaching Lyon, I took out the fan Mme — gave me as a gift for Isabel. It shows the prospect from the topmost window of her home. I watch as she appears from the patchy shade of orange trees. She descends the stairway and steps forward, her head tilted to catch the sound of distant water, and she walks toward the bridge which spans the sepia lake.

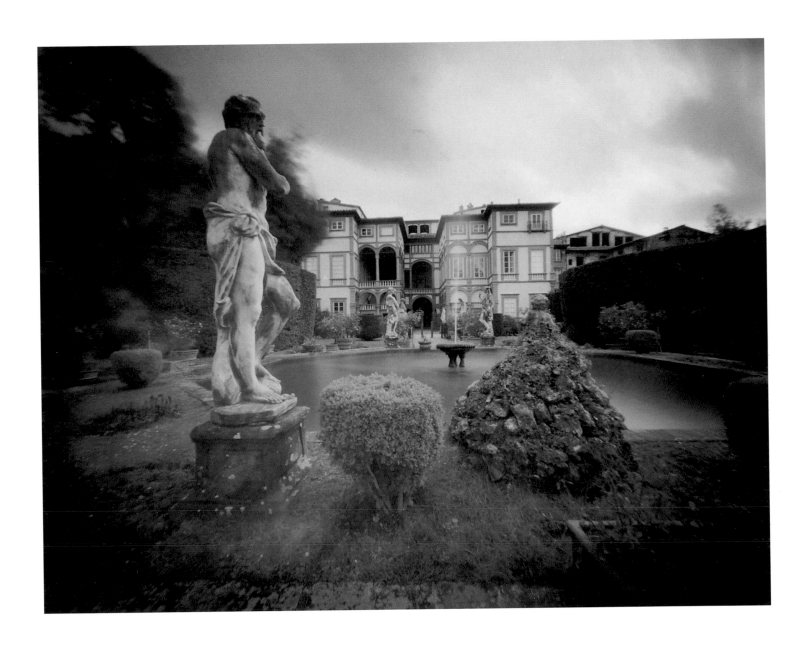

After Robert Pinnacle's
'Figure of Zeus in the Palace Gardens'

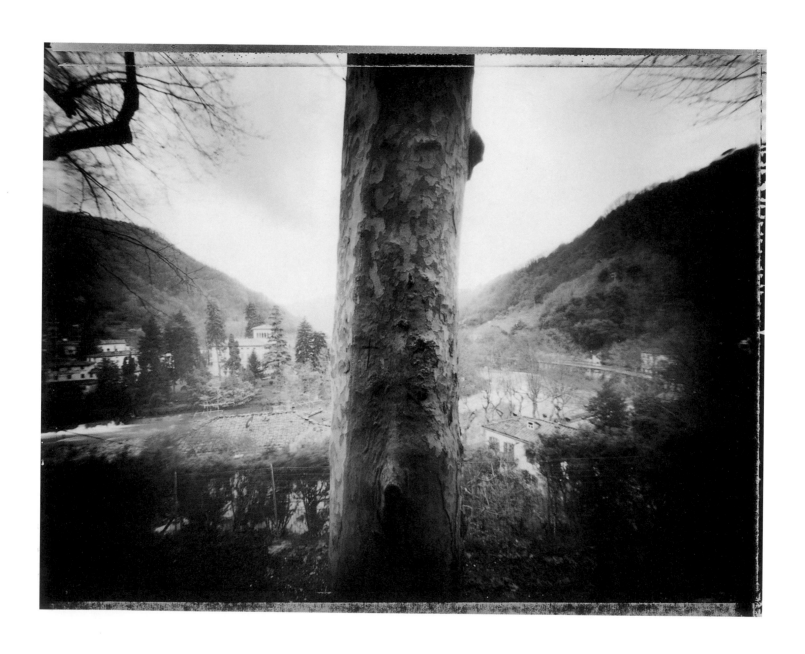

After Robert Pinnacle's
'View across the Lima of the Villa Fiori'

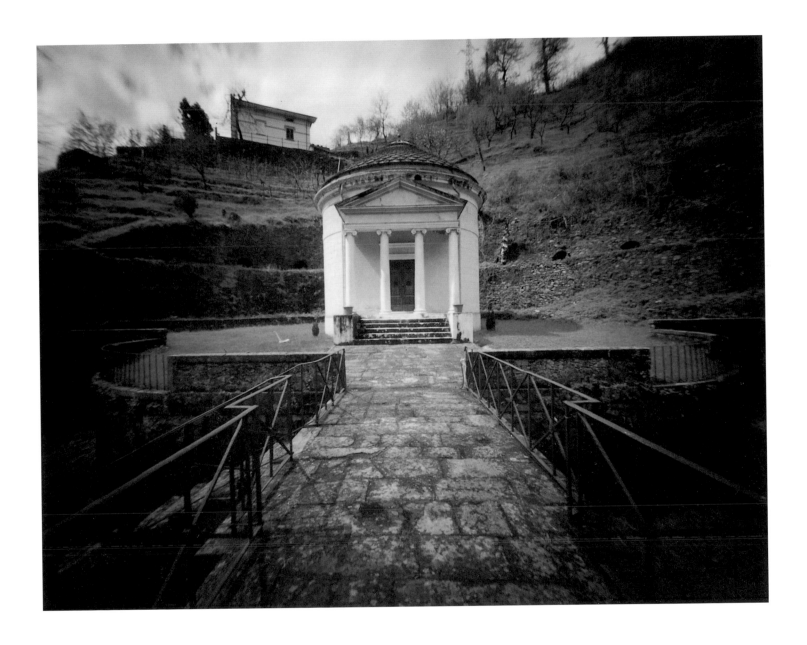

After Robert Pinnacle's
'Tempietto Demidoff'

Maritata

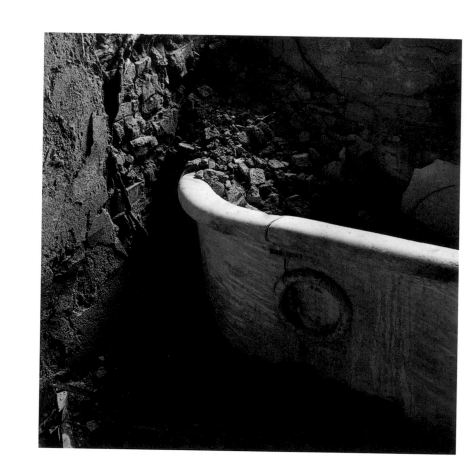

 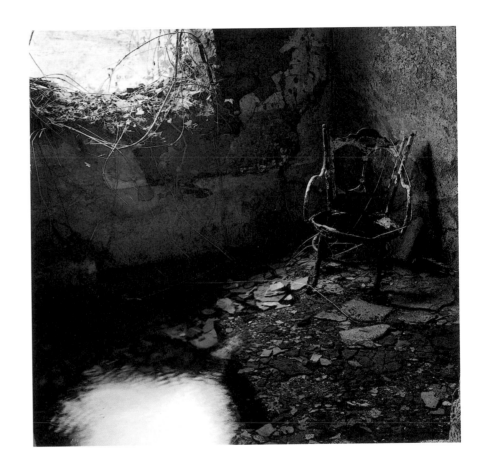

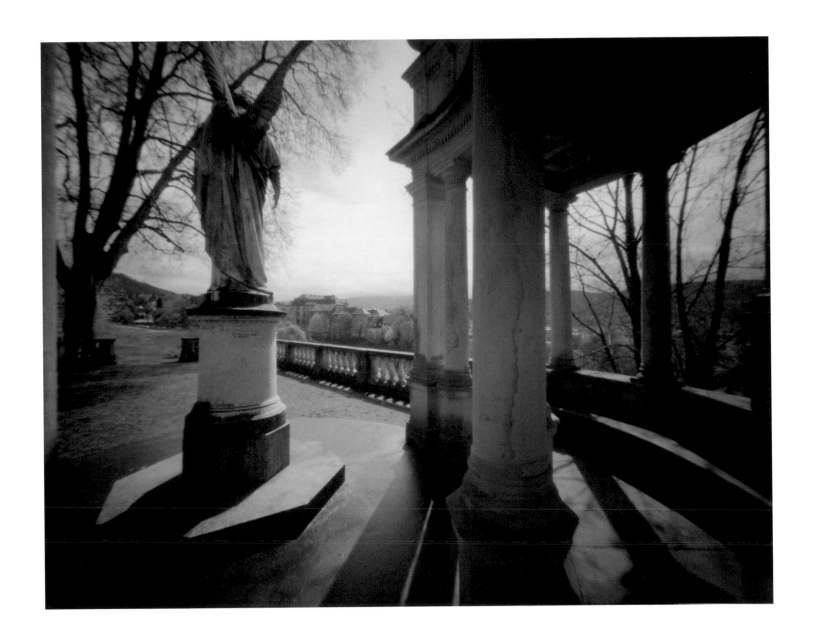

After Robert Pinnacle's
'Prospects of the Schloss in Baden-Baden'

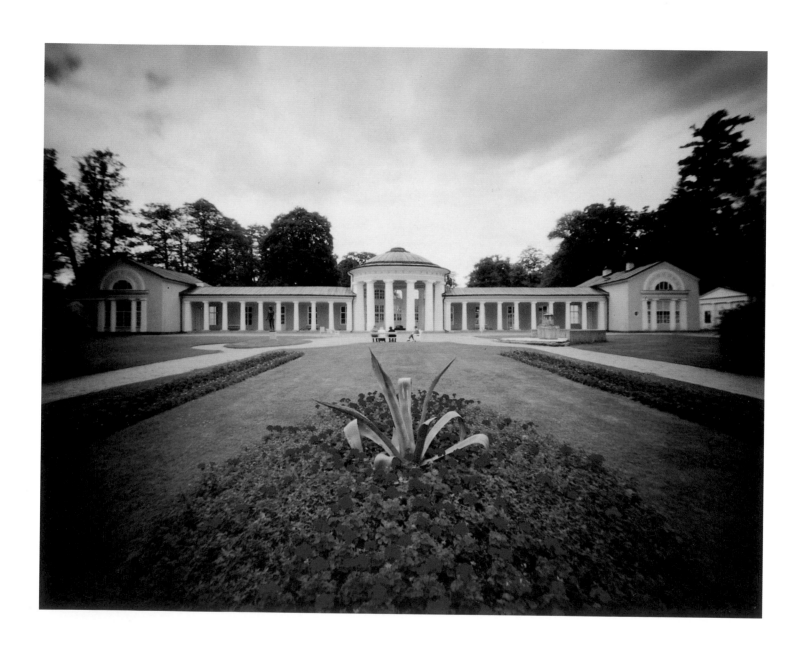

After Robert Pinnacle's
'The Ferdinand Spring at Marienbad'

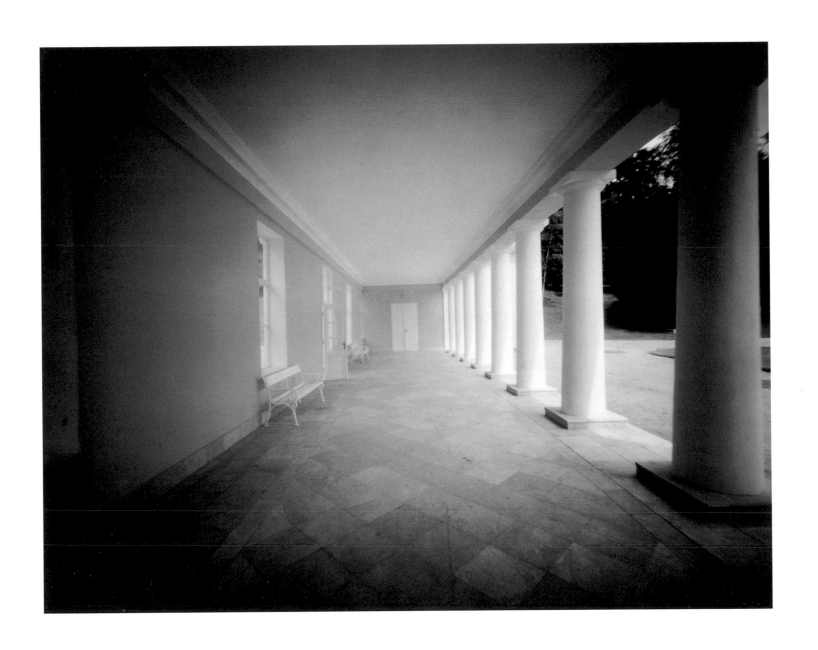

After Robert Pinnacle's
'Promenading at the Ferdinand Spring'

Extract from Robert Pinnacle's journals —

...I had never made a likeness of myself, leaving it to those handsome fellows like Barker (who had always seemed to find some pretext for regarding himself in the mirror). The daughters insisted I had my portrait made via this astonishing new method. After all I had said in its dis-favour I suspect they merely wished to tease me.

The image would never be as permanent as that executed with oil paint – (but then, I conceded, so much depended on the painter's method and the ambience in which the canvas hung). It appeared that in order to make a picture dealing with the current vogue for the historical, moral epic so many exposures must be made and then cut up and masked, and all the rest of it and, in my view, at the end of this it could never attain the drama even of a half-decent oil or watercolour. It held, though, undoubted fascination...

...I had been shown a remarkable image of bonnets, and the mere notion of the waves of light from these delicate objets of lace and ribbon radiating through the air to be caught and held as though something of their essence had been spirited across the room, moved me greatly. What I could not come to terms with, I suppose, was that the author of these images (I cannot refer to him as an artist) need have no skill with brush or pen and need not spend long years studying this discipline, or possess any natural talents for draughtsmanship.

Antoinette and Caroline took me to their friend's studio where I was made to sit before a painted cloth as though on stage at the theatre. The cloth showed a landscape depicting a distant castle seen through a semi-circle of columns and with the statue of an angel looking over. It was so like the painting I did for good old Heinrich all those years ago that I would have split my sides if laughing did not make me cough so. As this always agitated the girls, I simply smiled.

I was requested to sit there with my eyes closed. It seemed I had to keep them shut for a very long time.

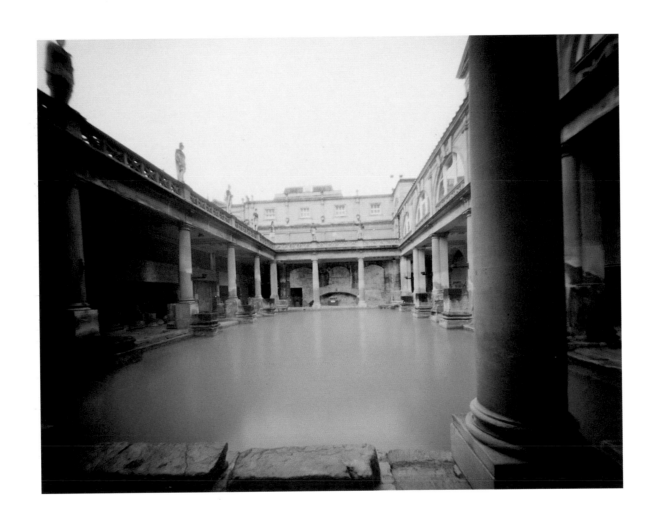

After Robert Pinnacle's
'Imaginary view of the Roman Baths'

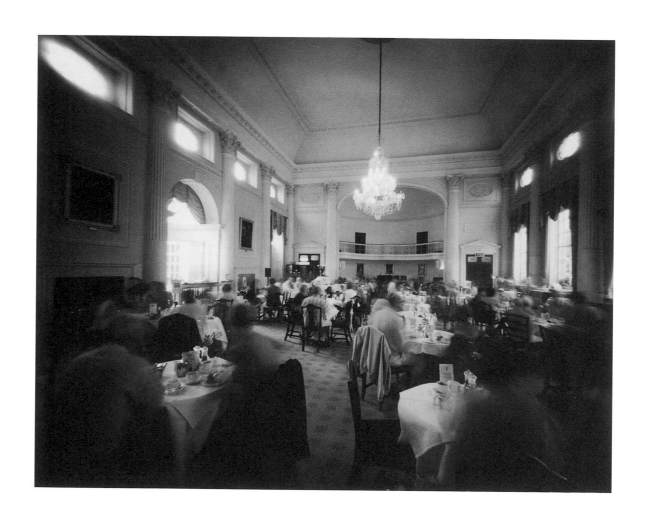

After Robert Pinnacle's
'Interior of the Pump Room'

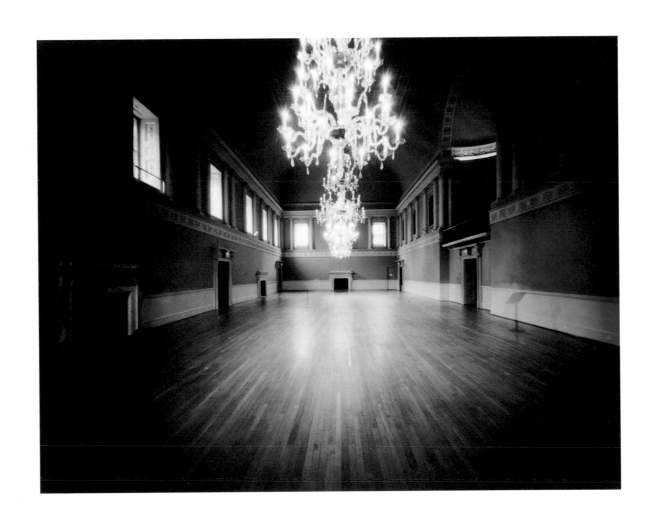

After Robert Pinnacle's
'Interior of the Assembly Rooms'

Persons of Substance

Robert Pinnacle is a fictional character and bears a passing resemblance
to a number of persons both living and dead

ROSHINI KEMPADOO

THE HEAD PEOPLE
FROM THE SERIES 'SWEETNESS AND LIGHT'

What, fundamentally, is colonization? The decisive actors here are the adventurer and the pirate, the wholesale grocer and the ship owner, the gold digger and the merchant; appetite and force.

AIMÉ CÉSAIRE Discourse on Colonialism 1955

Created from the starting point of someone whose ancestors were the 'subjects' of the colonial experience, the series, 'Sweetness and Light' explores the essence of the term 'colonialism' through the specific example of sugar plantations in the Caribbean during the fifteenth century. It combines icons of new technologies and representations of the British landscape to examine some of the social and psychological strategies put in place to create a successful economic entity such as manufacturing sugar. 'The Head People' not only references this past but also acknowledges cyberspace as a new arena for venture capital with its power hierarchies and systems of appropriation and exploitation.

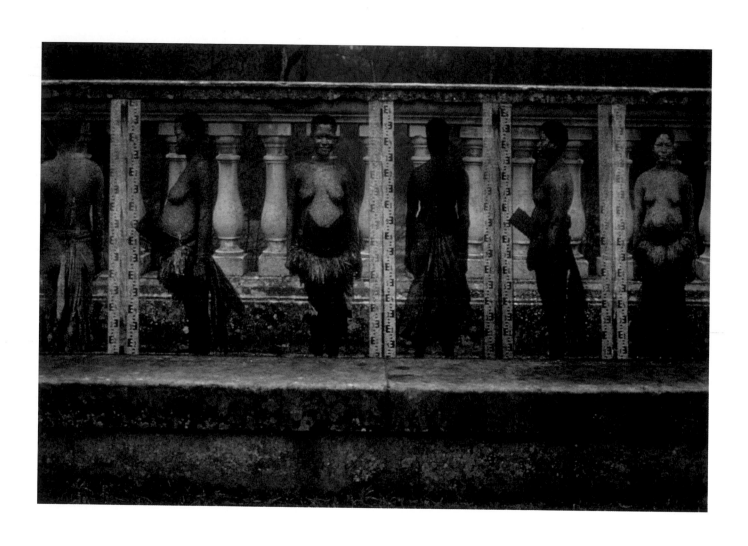

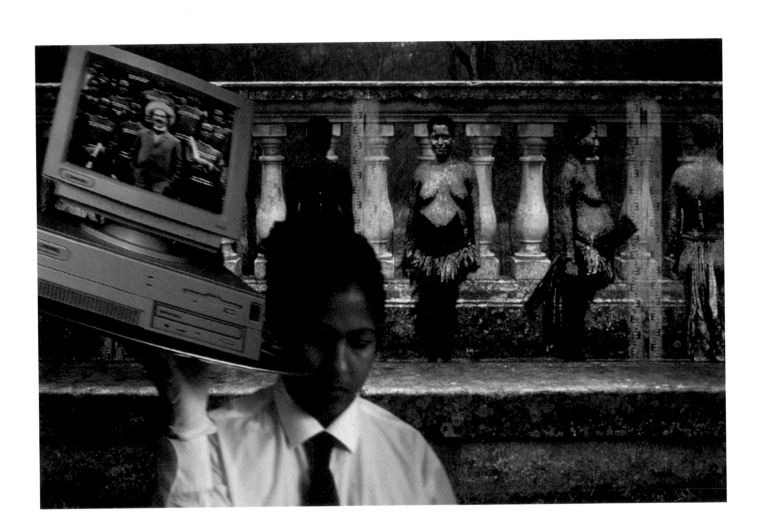

Envisioning:
Processes and Practices

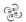

Liz Wells

Introduction

Readers flick through books. Visitors to art galleries consume images ritually, pausing maybe for 30 seconds in front of a picture, perhaps taking a little longer to engage with installations. Yet each image, installation, portfolio or series results from serious exploration of particular ideas, and from commitment to communication. In making work for publication or for the gallery the artist sets out to affect the viewer, to offer pleasures which may both delight and disturb.

Creative production is founded upon in-depth research and development processes; but these remain largely hidden. In Britain, recently, there have been attempts to better comprehend the relation between research and practice.[1] In particular, debates have focused on the nature of research into practice, on questions of what constitutes originality in practice-based research, and on how to identify and talk about experimentation within creativity. Co-curating *Shifting Horizons* gave me an opportunity to ask the artists about their approach to project research and realization.[2]

Curators and editors have privileged access to artists. We are among few who sometimes get to see some of what has been discarded, or transcended, in the journey of exploration which forms the creative process. This process is always fragile, involving retreats from cul de sacs, and panic in blind alleys. We know something of this from diaries kept by writers and artists, but it is relatively rarely discussed (except in biographies). As one of the artists remarked, as a lecturer

and artist she is quite confident about talking about her work in itself, but less accustomed to discussing experiences involved in researching, developing and making the work. Indeed, such processes remain private, except where artists have chosen to meet regularly, whether this be within a formal forum such as a taught MA[3] or through self-managed workshops.[4]

This essay is based upon comparing approaches to project development.[5] Thus it focuses, in turn, on research processes, on the purposes and contexts in which work is made, on the intentions of the artist, on titles and on being a woman and an artist. In addition some reference is made to technologies and to funding issues. All the artists had pertinent comments and experiences to recount; inevitably it has not been possible to include every story. Hence, in relation to each topic, I have selected a few examples for particular attention, using comments and quotes from each of the artists to enliven the general discussion.

Overall I was struck by convergences of views and objectives despite, as can be seen from the portfolios, distinctly different practices. This is not entirely surprising; for a start, all have chosen to be members of the IRIS women's photography resource and, as such, acknowledge themselves as women artists although none would actually describe herself in this way. Nonetheless, gender is pertinent, not only in stories told about circumstances and experiences, but also in the remarkably organic, non-linear, 'feminine' ways of working which characterize research explorations.

The feminine, as a term referencing both behaviour and sensibilities, is not exclusively associated with women. However, our experience is gendered, and this necessarily infects and inflects creative practice.[6]

All the artists are interventionist, variously aiming to alert us to issues and to subvert more traditional aesthetics. All view ideas as more important than technology, but note ways in which the actual physical process of making is marked in the resultant imagery. Differences of approach did emerge, particularly as a consequence of differing types of practice. Ways of working also reflect personality and particular histories, domestic contexts and constraints. Overall, however, it seemed that each artist has found operating patterns which work well enough for her.

Research as Exploration

Research can feel messy, rather than methodological. 'Method in her madness' is a phrase which might have been coined to express something of the serendipity, and freedom of the associative, implicated.

All the artists emphasised intuition and fluidity within project development. As Åsa Andersson notes, 'it's not like I'm driven by an idea which I'm consciously exploring, it's more intuitive – everything can't be described or determined'. Thus her work, which now often takes the form of a layering of two slides, is based upon images made because she has been drawn to some feature intuitively and

emotionally. 'I have got better at defending this.' She reflects upon projects, and this reflective process or experience becomes 'intuition for the next project'. Although her concerns are very different, Lou Spence also 'accepts a reasonably intuitive way of making photographs', the concerns that have initiated them sometimes only becoming apparent on viewing the prints.

The artists also all emphasized the centrality of research. Some work in a fairly systematic, library-based fashion; others explore primarily through 'note-taking' with the camera – although reading and observation are never mutually exclusive. Several take a very open approach to their work. For instance, Gina Glover says she works in an eclectic manner, as well as being highly intuitive. Her research involves working on location, in-depth interviews, photographic sketchbooks and what she terms painting with her camera. Reading around the subject includes poetry as well as more factual writings, philosophical and neuroscience texts. Personal meditation and reflection on the work of others also informs her practice. Likewise, Su Grierson's sources are broad. She reads books on contemporary science – including the brain and mind-mapping – philosophy and human nature, and the physiological expansion of knowledge which 'help me see possibilities when I'm playing with the computer' and is interested in perception and how vision can affect what and how we think. Her video installations express her interest in perception, colour and movement. Her photographic and digital images are often derived from video footage taken when travelling. Some projects challenge traditional form, others explore the relationship between the image and the viewer. She describes her research as very circular, non-linear, organic.

Here, the relation between the particularities of the specific medium and modes of expression is central. To 'play'

with the computer or to 'note-take' with the camera is to explore and experiment with photographic seeing or with the interactivity of the computer as well as to sift the inter-relation of the visual and the philosophic in connection with a specific issue or idea.

Michelle Atherton is particularly interested in the materiality of photographs. Projects act as focus points or springboards, but there is no specific beginning or end to the research process. Her work comes from an amalgamation of areas and she oscillates between production and theoretical reading. 'What I select to read may be very specific, so the work is a response to reading and also to the ontological debates relating to photography.' Much of her work has taken the form of site-specific installation. She is interested in the mundane spaces that we exist in and pass through on a day-to-day basis. Theories play a part in fuelling the work, which may in its turn serve to make shifts within a discourse. She emphasizes the idea of *taking* a photograph. 'For me it is about *taking* because the photographs come out of a sifting process, a sifting from a pool of existing visual images. I take from it in order to question everyday perspectives.'

Åsa uses the camera both for sketchbook work, when thinking about objects in terms of sculpture and installation, and in order to create photo-based images. Previously she used photography to document sculpture and installations. But recently she has worked with photography as a means of exploring space, both the space beyond the camera and the space within the photo.

What is interesting and what has been liberating is that the photographic medium has enabled me to work in a mode which is more flexible in that the environments and objects I photograph may only last for ten seconds rather than being elaborately structured. The camera helps me to frame 'miniature-worlds' within the world and the process of

layering creates yet another unexpected aspect and perspective from which to view the world.

Likewise, for Julia Peck, initial ideas come visually; she develops them through photographing, at that stage on medium format. Later she re-shoots on large format.

Emphasis may be upon observation. But, what is seen, and how it is framed – in terms of knowledge and through the rectangle of the viewfinder – is informed by personal history. For instance, Sian Bonnell describes her work as about understanding space and about memory, by which she means both unconscious childhood memory, some of which resurfaces subsequent to the making of particular pieces of work, and collective memory, inscribed variously in local culture.[7] Research, for her, is about looking repeatedly at particular places, seeking out detail which can inform her exploration of the environment. Her original training as a sculptor has left its mark in her concern with form and with scale. She emphasizes an evolutionary process, being open to projects shifting and changing.

Props may offer a starting point. Sian collects toys and souvenirs, leaves, twigs and feathers, and kitchen utensils shaped to reference the rural; all inform her interest in relations between inside and outside. In a previous project, *Groundings*, she took objects from her kitchen and photographed them out of doors, for instance, the sheep-shaped biscuit cutter which she used to cut sandwiches in order to encourage the children to eat. Subsequently she raided junk shops and car boot sales, increasing her repertoire of utensils. *Undercurrents* includes seaside souvenirs - the cuddly seal, chosen by one of her sons as his holiday present one year in St Davids, which looks distinctly alarmed beached on the ridged rocks, or the miniature lighthouse which, placed on a boulder, shifts the whole sense of scale within the picture. Likewise, Åsa collects and keeps a

stock of props – a stuffed leather anchor, cloths, also flowers and fruit, all of which are re-used in various sites then photographed.

Liz Nicol also views herself as investigative and describes her process of 'taking and making photographs (as) one of drawing attention to and making sense of'. She photographs objects found in museums, churches, zoos, aquariums, in the streets and in her home and is concerned with the relationship of objects to photographs.[8] Although she studied photography, she has long had an interest in fabrics, and in the tactile and emotional dimensions of objects in space. Thus she describes a research 'dialogue' between herself and the locations which she is exploring. As with Sian, her work is based upon collecting, finding herself interested in particular objects or images. 'I start with something, and I play with it, and it sits in a drawer for a while, and then it comes to the front of my mind.' Previously she took photographs as a method of collecting, now she is as likely to collect the actual object (for instance, rubber bands). Her work process is 'sculptural' in its physicality; this is extended through the process of presentation wherein she pays attention to display. For Liz, the potential for a project to develop exists at the point of collecting, when she realises that objects are amassing, although, as with all the artists, the gestation process may take several years.

By contrast, Sally Waterman's interest is in narrative and the art of storytelling.[9] She defines herself as an 'image-maker', doing literary adaptations (in the manner of adaptations for film) using staged settings and operating directorially. Thus she places herself somewhere other than as 'artist' or as 'photographer' taking, as her starting point, 'something that triggers', perhaps an object or a location or, more usually, a text. With *The Waves* her approach was very methodical, commencing from personal identification, through 'brainstorming' to select sequences or aspects of the novel. This led her to examine a number of critical issues, for instance, what processes are central to the translation from one form, the novel, to another, the image? What is reading about, and how does 'reading' a photograph differ from reading a novel? How best to approach a text for adaptation purposes, in terms of narrative, or character? The sketchbook is central to her research process. It functions as a diary, as a notebook for contacts; also for cuttings and quotes drawn from fiction and from more critical texts. She describes her way of working with models as 'quite organic'. Images are not fully pre-conceived, rather she has 'something in the mind's eye, an idea, a starting point' then, together with her models (usually friends), she constructs scenarios which illustrate an image or a scene.

There are distinctions between 'taking' photographs, using montage as method, or 'making' images based upon constructed scenarios and working with models. There are also distinctions between exploring through observation, response to space, and the collecting of images and objects, and the more explicitly historical or political concerns which lead to archive-based research. But this is a question of balance: all the artists draw on library research, and all 'play' with visual ideas. Roshini Kempadoo's concerns are sociopolitical, and her research always draws extensively on public archives internationally, but she often starts a new project with an image. She uses quotes from contemporary and historic writings, fiction and non-fiction, including press cuttings alongside more academic historical resources, such as anti-slavery documents, as well as contemporary post-colonial theory. She collects and digitizes materials so that she has her own developing archive of resources.[10] Her method combines the academic with more intuitive visual experimentation.

Similarly, considering the terms of the society which grew up around spas historically and linking this with the history of photography as a recording device, questioning the role of the artist, led Kate Mellor into wide-ranging research including the academic, tabloids, radio, talking to people, contemporary fiction and poetry. She describes fiction and poetry as a different route to 'truth'. The academic includes the scientific. 'I take in as much as I can until it's all swilling around like a huge soup. Then it has to be narrowed down.' In this instance the conceit of 'Robert Pinnacle', an imaginary 'amalgam' figure emerged. She was interested in the image of the artist portrayed in popular culture, especially fiction, and in what this reveals about specific desires of society projected onto artists. Pinnacle thrives because of qualities other than being a skilful painter. So, her intention was a bit of a 'piss taker' in terms of the role of the artist and his aspirations. Given that the project was based on actual history, he was inevitably a male figure. She adds that the artist would have to pander to that sort of society and a woman would not have been in that sort of role, 'It's a complete fiction, but one doesn't want to leave logic entirely aside!'

Overall, what is notable is the range of sources and resources drawn into play. All the artists work heuristically, discovering through enquiry, and all seemed remarkably open and methodologically undogmatic in their approach, letting systems appropriate to particular projects emerge. It is tempting to speculate whether or not this is particularly associated with women as artists; however, that would be to move beyond both the scope of this essay and the interview material on which it draws.

TECHNICALITIES

Given the long history in photography of technophilia – or f-stop fanaticism – it was interesting to note that none of the artists mentioned the technical in its own right. Rather technique and technicalities become concerns only in conjunction with the demands of particular ideas. For instance, for Kate, the use of the pinhole camera in *Robert Pinnacle* reflects the fact that artists used pinholes as a tool. (She sees 'Pinnacle type' landscape painters as forerunners of todays landscape photographers.) She wanted to build into the work questions about history and, as part of this, about the history of photography. For this reason she used a range of formats and processes from pinholes (earliest record of effects dates from 2000 BC) to the digital. She matches photo processes to particular ideas and to what can be said using that aesthetic. 'In the beginning the technical gets in the way as it holds up the creative process, although as you get more experienced you find you really do know quite a lot.'

It is the actual process of making images which reveals what Liz is doing. She describes the process as physical, playful and responsive. The making of images involves physical contact with that which she has collected, as the work is made through photograms (using a sunbed for contact exposure). By contrast, Roshini's production method is now entirely digital, and final images are planned with manipulation already in mind.[11] Her montages always question race and gender, power and exploitation; questions of history are articulated, but through both using, and interrogating the implications of, new technologies.

Although lacking masculine obsession with the technical, these examples all testify to an awareness of discourses of technology, but the means of production remain subservient to image as expression.

FUNDING SOURCES

All the artists experience some tension between the freedoms of personal work and the need for finance given costs of studio facilities, film stock, cameras, travel costs and so on. They tend to combine commissions, teaching and sales of work as income-sources. Some sell through picture agencies. For example, Roshini remains an associate member of Format, the women's photography agency, for documentary stills, and is a member of Autograph, The Association of Black Photographers, for digital work. Sally is represented by Millennium Picture Library and has sold a number of works through them, for instance, for book covers. Her work is always self-generated which means that, as she puts it, she is 'not constrained by art directors'. She prefers to make work 'freely' – if it sells that is a bonus.

Kate also feels that the best work comes from artists' own concerns and knowledge. Commissions may stretch creativity, but they may have inbuilt constraints. For instance, *In the footsteps of Robert Pinnacle* was a commission with a fairly open brief to look at European spa towns, but it *had to include* Harrogate. Commissions may involve very fast, perhaps over fast, research. Most commissions come through in November, but landscape projects take a long time conceptually, in terms of working within the seasonal restrictions of natural light, and also in terms of travel time and getting to know a place. Access to locations can be difficult, especially if you are trying to do a commission in the space of a few months.[12] However, work which has been commissioned gets shown. This means that you know in advance that you will have an audience. It is difficult to get galleries to show self-generated work, and equally difficult to cover the costs of showing in non-gallery spaces.

Gina has adopted a sort of 'parallel tracks' solution. She

was a photojournalist for many years. Then she was ill and unable to work professionally for four years in the early nineties.[13] This proved a turning point. Aside from her more personal work, she now seeks bursaries and commissions working with staff and patients in psychiatric hospitals both to run workshops and to document the environment.[14] Exhibition is assured, although imagery may remain within the institution rather than being on public display. Her own creativity is challenged; for instance, since she is not permitted to photograph the patients themselves, she has been exploring how traces of mental illness can be read through the fabric of objects or furniture, for example, cigarette stub marks on tables or carpets which have been ironed. Such work pushes her to more elliptical modes of image-making.

Several teach alongside their own work; and Su has used the lecture tour to support travel.[15] Liz quite specifically noted that her position as a university lecturer supports her practice (viewed by the university as a form of research). This not only offers funding, but also opportunities for questioning and discussion in research forums and when teaching.

INTERVENTIONS

Radicalism in art is interventionist. New means of visual communication are sought in order to make memorable impact, to disrupt that which might otherwise be taken for granted, to interfere with accustomed aesthetics, to explore the seams of the semiotic.

Julia is centrally interested in the visual, 'in what you can say visually, in visual strategies'. Photography, and the gaze, are strongly linked and she questions visual pleasure, wondering, in theoretical terms, whether it can ever be legitimate to make and take enjoyment in the gaze to which

photography is tied. She is also interested in what she termed 'the meeting place between intuition and conceptual content'. Working in landscape can become a complex experience:

the environment is bigger than you, and the noises become frightening ... I have never been afraid for my life, but have sometimes felt unease and certainly not at peace with the environment.

She delves into this environment, in her current work using tiny depth of field to be really inside of bushes; an uncomfortable and uneasy space. Her imagery is relatively abstract and she acknowledges the influence of American formalism. In her view art should offer space for contemplation. This stems from her passion for things and places which are beautiful. 'The sublime has had a small revival in modern art in terms of shock and feelings of horror. Contemplation is a very sticky issue, however.' She hopes people will *experience* work, rather than consume it.

For Åsa the issue is how to find one's own voice, to articulate what she sees as a 'fluent' relationship, especially within an academic framework. Here she stresses the necessary relation between philosophy and fine art. Negotiations are constant: sometimes a philosophical theme, such as issues of spatiality and temporality, emerges through making of work; sometimes philosophical discussion stimulates new considerations or material within her art practice. Her PhD dissertation was about intimacy in terms which examined a quality of encounter with objects or places which is sensuous, 'that moment which resists explanation, yet one is strongly affected...'.

Michelle's main interest is in dialogue around issues of spectatorship and in interrogation of certain spaces. Photographs have frames, but Michelle is trying to move away from the traditional image in ways that unsettle the framing effect. She remarks that you capture your person or subject on film, thereby positioning the person or subject. Her piece 'Cornered' was a small corner piece photograph of a male figure. Normally the female position is the marginal position; here the male figure is marginalised, although, as she remarks, issues relating to patriarchy and equality cannot be raised simply through direct swapping of position. But she's 'pushing back on the spectator by a process of disturbance'. Her work uses tricks, but is more than a trick as she is always concerned to think about spectatorship.

Lou is also concerned with viewing, and sets out to avoid the conformity of landscape aesthetics, noting that cultural expectations and landscape sensibilities determine the public viewing of our countryside and set up false expectations of the agricultural landscape. *Maddle Farm* is both the place where she grew up and a personal response to the crisis of British agriculture which became a major factor in the potential end of an era for her family farm. As agricultural policies make the small family-run farm economically unviable for the current generation, a traditional way of life becomes unsustainable. She sees making gallery-based work as a means of penetrating urban consciousness. Julia likewise refuses 'certain typical conventions of landscape: the horizon, the high vantage point, the gaze of acquisitional ownership, etc.' But her work is typical of landscape in that it uses aesthetic rhetorics including the seductiveness of colour. With *Face* she sought flatness, a sense of wall directly in front, no ground or sky, disorienting feeling of space, enclosure. One aim is to dissolve the effect of the frame of the photograph so that the experience of the image is more immersive:

The viewer is confronted by the faces and made uncomfortable with being enclosed. A quarry as a space is something that prevents us from moving out, seeing out and is restrictive. The work aims to mimic this experience, each image is tightly cropped and we do not know where the walls begin and end. The viewing is an encounter rather than something to be packaged and taken away with you. The trees become figurative and the fissures reflect the gestures of the trees. At this size (152 cm x 122 cm inch gallery prints) we become aware of our own presence, the differences and similarities in scale and the relationship to ourselves.

As Su remarks, 'Vision activates so many parts of the brain. Does vision have the power to alter the way we see (understand) things?' Her work aims to take us beyond points of comfort. For instance, her title, *Scenario*, reflects the use of this term in business think-tanks challenged to imagine responses to that which does not seem possible. Her early digital explorations revealed the possibility of utilizing the zones of instability that can be found within technology: an early piece, *Collapse*, which engages intense polar opposite reds and greens, caused the computer to collapse in that it ran at reduced speed. Contrary to prevalent assumptions, the technology cannot necessarily hold stability when dealing in binary opposites. As with all the artists, she is interested in points of instability which allow space for change.

TITLES AND WRITING

The majority of the artists find titling problematic, acknowledging the extent to which titles influence audience response. As Sally remarked, straightforward titles may over-simplify, but elusive titles may exclude the viewer. All seek resonances which get to the heart of the work and reflect cultural complexities appropriately, given the particular aesthetic. In addition titles have a P R dimension; marketing concerns affect titles in both exhibition and publishing.

Often the title comes last: Michelle does not even think about titles until after the work is made. Sian describes the

process of titling as evolutionary: individual images are pre-conceived, but each series is crystallized through editing and the title comes at the point when she knows she is about to stop a particular line of visual exploration.[17] Julia initially refused the idea of of titling as she didn't want to use titles to 'illustrate' images, for instance, phrases such as 'quarry in Derbyshire' or 'flat surface with colour'. Now she lets the title emerge after work is finished, still finding it difficult to find the word that sums up her work given that the process is very abstract. For instance, at first her quarry work was titled 'Silenced Earth' but now she finds that too romantic and prefers the more literal and cryptic statement, *Face*. By contrast, Gina considers titles right from the beginning as they help her to place a piece of work. 'Working from a solid starting point allows me to fly'. Likewise, Åsa notes that *Writing Water in its Absence* was formed from the work, but then framed the making of further images.

Two seemed more relaxed about titling; interestingly both read fine art (rather than photography) and are process-oriented, which may contribute to accounting for a more fluid attitude. Su changes titles, seeing no necessity to label work forever. She also remarks that 'A title has to really hit the right point in a work, but I don't mind if this is quite a simple, banal point'. For Liz straightforward titles locate her projects in terms of collecting and categorization; literal titles 'ground' the work, countering the abstract visuals. For instance, 'The River Exe, Swans Feathers, cyanotype' located the blue horizontal strip included in *Littoral*, a group show based at what was the Exeter Maritime Museum.[18] Michelle notes that correspondences between titles and images are important as they add a sub-text to the work. With *Park* the time of day when the image was made is a key element in how each piece works with the viewer. *Park* is the overall title but

'the images are about sense, distortion and a contradiction of emotional feelings that can go on in a particular space. That they're all parks is important because of public access, but I would not say that this work is about parks *per se* '. Whether functioning primarily literally, or operating more poetically, titles exercise the artist – precisely because they contribute to focusing the viewer.

Poetics may also resonate through graphic style. For instance, in incorporating quotes, partly to keep the reference to *The Waves* live, Sally decided to use her own handwriting to express personal involvement. She comments that the editing process, including allying quotes with images, is just as important as the original intention: overall she wanted to express a sense of 'English sadness', a restrained melancholy. Åsa also commented on writing, noting, in relation to *Writing Water in its Absence*, that the poetics of communication is evident through use of graphic traces, suggestions of writing, rather than actual words. Here, both Sally and Åsa are identifying the *implications* of writing, especially handwriting, rather than questions of word and meaning.

ON BEING A WOMAN AND AN ARTIST

All acknowledged issues associated with the feminine, or with being a woman and an artist. Whilst none nowadays would insist on labelling themselves as women artists, all made some reference to the feminine within their practice. For example, Sally specifically noted that research on gender and identity in art and literature, the influence of feminism, and her interest in the work of women writers, are philosophically central to her work. Likewise, being a woman influences the nature of Gina's work, both its overt personal starting points and the locations. The garden is not obviously either a male or a female domain, but as a setting it references

nurturing (generally associated with the feminine). But for her, the central issue is communicating as an artist, finding ways of making personal work that has broader resonances for a wide audience.

Here, there is an awareness of changes which have occurred over the past 30 years or so. As Gina remarks, to declare yourself a woman artist at art college (Chelsea) in the 1960s would have been greeted with the injunction to 'go home and knit'! Liz remembers 'In the early days I was working oblivious of being a woman ... I had no women role models'. In the past she felt she had to fight to be taken seriously as both an artist and a lecturer, especially because of working with the decorative and feeling that what she wanted to do might be belittled. 'I don't think I'm exclusive in working with the things around me – male artists do it – but I think I have much more in common and to share with women practitioners.' When teaching foundation students, she started working more autobiographically, at the same time wondering who would be interested in her autobiography. Later, working in fine art ('very much an old boys network'), she felt that she was at the bottom of the heap as a young woman working in photography which, along with ceramics, was viewed as inferior due to being process-oriented.

Julia, nearly a generation younger, feels that being a woman only influences her work in mundane ways, for instance, it takes strength to carry a large format camera. Similarly pragmatically, Michelle remarked that she took someone with her when shooting *Park* as it was at night and it would be silly not to recognize vulnerability, especially with cumbersome and/or valuable equipment. Company gave her freedom to concentrate on what she was doing as she did not have to remain alert to threat. Julia also commented,

I think the reading and the knowledge of past struggles of women to practice does influence what I think and how I view my position now. I do not fool myself that I am working in an equal world, but many of the practical obstacles that women artists have faced in the past are now not so predominant (for example, it is not a problem to be single and living independently of the family). I recognise that for women with families life is still very difficult, but this is ... beyond my experience.

More generally, she feels that 'needing and wanting to practice is more important than making a statement about being a woman artist'. She sees women's artistic practices gaining ground and feels encouraged by this especially where we begin to recognize diversity within women's practice. She acknowledges the contact and support she had when working with a group of women artists. She distinguishes this from the 'networking and dealing' she has experienced working with male artists (although notes that she is sure there are plenty of men who support each other in their practice).

Roshini adds that, working with new technology, she continues to encounter absent-minded sexism: students tend to direct technical questions to male colleagues and, she commented, 'the "geek" is quite young and quite male'. But then, as she remarks, what's new? The phenomenon of 'f-stop obsession' is familiar to all who work in photography. In relation to the digital, she notes a need for active discussions focused on gender, media and art, and for support among women. It is worth re-iterating that those for whom technology is central, such as Roshini and Su, eschew technophilia.

More generally, it seems that it is not being a woman so much as being a parent which limits explorations. Liz's *Rubber Band* project started as a pastime pursued with her son, an avid collector, and consumer, on the way to and from school. 'I can talk about it in terms of gallery work, but I can also talk about it in terms of my son and other things very close to me.'[19] Likewise, Sian moved from London to Dorset in 1991 and views her recent work as part of a process of exploring her new environment, of putting down roots; also, anxiety to make a good home for the children. By 'home' she means locality, as well as household. Living in a village, she used to drop the boys at school, then go for a two-mile walk every morning so, over the years, she became familiar with the local environment and with the effects of seasonal change. Most of her work is made in winter. This is partly because of quality of light, but also because the boys are at school so she has more time.

Lou feels that being a woman doesn't affect her way of working, the open landscape (family farm) is a familiar space, although 'the practice and the aesthetics obviously jar against the landscape tradition'. She notes that in the male dominated domains of both agricultural practice and landscape portrayal she maybe has a more feminine emotional response to her surroundings. Like Lou, Su has lived on and worked the family farm so landscape is not alien space. Regarding gender, she notes the dangers of stereotyping but comments that 'the men I know tend to function in a more linear way, don't like change, like to know where the boundaries are'. She suggests that there is a female interest in passage through landscape, rather than in domination and control, and tells an apocryphal story of the traditional landscape painter in Tasmania who kept labourers on standby to chop down trees to create the ideal view for him to paint! Likewise, Kate comments that, archetypically, male photographers stand on top of a rock or a mountain and look down, and women explore in more intimate, close-up ways. 'Culturally speaking women are now taking on the role of explorers in some ways, but you still find yourself experiencing landscape as culturally inherited ... how you see is culturally learnt'. As women our experiences of environment are formed and framed through the influences of a traditional landscape aesthetic, in its turn, informed by gender.

There is a distinction between, on the one hand, recognizing the struggles which, in the past, have been faced by women artists and, indeed, by artists working in photography, and, on the other hand, acknowledging distinctions between the masculine and the feminine and ways in which these are articulated within work. For instance Åsa comments, 'my work is quite gendered, but I am not working with issues of gender'. Rather her concern with intimate spaces, layering (for instance, between clothing and skin), references the feminine and lends vulnerability. She also questions notions of the feminine: for instance, how might one talk about feminine sensibility in relation to an object which is red/pink, velvet, but incorporates concrete? She is interested in the resonance between the otherness of objects or materials, the distance between them, and yet the immediacy of their presence.

Likewise, Michelle notes that being a woman influences her work 'completely, as I am in the position of being a woman whether I like it or not. It involves a complex set of relations that cannot be simplistically identified, as is clear from contemporary (post-) feminist debates.' The question of the effects and affects of being a woman is a very broad. Liz describes being a woman as becoming a lot more of a positive recognition and pleasure. The objects she uses are to do with a historical feminine, whether lace handkerchiefs or female figureheads for the prows of ships. The domestic is a big part of her work which involves decorative elements; the placing of objects within the photogram relates to display. Also, processes may be seen as gendered, for example, her work with paper involves cutting, tearing and wrapping paper

which is associated with women artists. Tearing is to do with a softening of the edge and is textural, rather than intellectual (as, for instance, in photomontage).

FLUXUS

Åsa grew up by the sea, and makes frequent allusion to water. Her piece *Harbour*, which encompasses the notion of 'arbor', incorporated reference to shelters: the allotment shed, the glasshouse, the beach hut, all in-between spaces. Sally articulates the personal elliptically: *The Waves* was made when she had just arrived in London and felt 'lost in a sea of people', in other words, she identified with the characters in terms of obsessions, emotions, personal feelings. Sian's work is at one level, an intellectual quest, but at another level, is seated in personal psychological and spiritual needs and is intricately bound up with the forging of a sense of belonging. Roshini always acknowledges her own position within the web of circumstances which she is investigating and invariably ends up putting herself, or members of her family, in the picture; as a black woman staging herself within the image, she is concerned to work against the stereotypes of exotic otherness, earth mother, and black female sexuality. This act of self-incorporation, although planned from the start, occurs towards the end of the work, perhaps helping her to draw a project to resolution, marking ways in which she herself is implicated within the histories which she has invoked. Diverse aesthetic strategies are used to invite us to reconsider our relation with 'landscape' as the artists variously exhibit concerns with position, identity, and belonging – be/longing.

Personal experience is influential, and acknowledged by all the artists; likewise, relations between personal or domestic circumstances and artistic aspirations. The fluidity of female experience is marked. In considering what the artists have to say about research processes and practices it is clear that this fluidity extends into artistic processes. Gendered experience is articulated with exploratory attitudes in which the intuitive and emotional are acknowledged as central to visual experimentation even where projects are explicitly underpinned through more academic interests and forms of research.

ENDNOTES

1 This has been driven, in particular, by a focus on research within British universities and art institutions. Formalization of practice-based research as M Phil or Ph D studies has induced a range of methodological debates relating to the inter-relation of theory and practice, to definitions of the innovatory in research into practice, and to attempts to position and take into account experimentation and creativity.

2 In organizing an exhibition it is quite normal for the curator to visit the artist at her studio, select work, and discuss ways of contextualizing the work – statements, titles and so on. Thus the curator may learn a lot about the creative process of the artist. This is not a situation of mutuality. In my experience artists ask about the proposed book or show, especially, who else is to be included and where will it tour. Rarely does the artist ask for the curator's c.v. or interrogate her about her work.

3 Several UK universities offer taught MAs which inter-relate theoretical concerns, questions of aesthetics and communication, and technical aspects of practice. Teaching is normally based upon weekly seminars and workshops in which students are acknowledged as the key source of expertise and mutual support.

4 For instance, Gina Glover was involved for several years in a group which met regularly to discuss and critique each other's ideas and also put on a number of group shows on self-portraiture. *Pathways to Memory* was first shown in 1999 as part of a four women exhibition, *Obsessions*.

5 The full interview notes can be found at the IRIS resource. The method was collaborative: each interview took two or three hours, then I wrote up my notes and sent them to the artist for checking. Discussion centred on:

 * source(s) of ideas for projects;
 * whether projects are usually self-generated or commissioned;
 * how the artists set about researching ideas;
 * how/where they seek locations;
 * whether being a woman influences work and ways of working;
 * titles;
 * new work and new directions.

6 See, in particular, Luce Irigaray (1993) 'Women's Discourse and Men's Discourse' and 'Writing As a Woman' in *je, tu, nous - Toward a Culture of Difference* (London: Routledge).

7 For instance, contemplating seasonal change over the centuries, Sian set about finding marks on Monmouth Beach at Lyme Regis (Dorset), which is renowned for fossils. Lyme also satisfies her interest in souvenirs, in treasures brought home from holidays and days out.

8 Liz references Anna Atkins as an influence. Anna Atkins, active in the mid-nineteenth-century and often cited as the first woman photographer, used cyanotypes to document flora and fauna in images which have a highly textured, relatively abstract appearance.

9 A graduate in English literature, Sally notes the influence of poetry and novels such as T. S. Eliot's *The Waste Land*, or Kate Chopin's *The Awakening*.

10 *Sweetness and Light* draws upon ninetennth-century documents and campaigns from the 1970s, both found in Marylebone Library, Westminster (London). Roshini notes a 'productive tension' between the older and more recent writings, through which the ideological becomes evident.

11 Thus, the shadowy figures in *The Head People* are sourced from an archive (the Smithsonian in Washington) whilst the columns and land which form the setting under interrogation were photographed at Windsor Great Park a symbol of wealth founded on exploitation.

12 The Spas project, and funding, was finalized in early 1998, shot and

first shown later that year. For landscape work this is very fast, so Kate had to travel, shooting and researching simultaneously, which led to taking a lot of photos that were not used as they turned out to go off at tangents; also to difficulties getting access to places or buildings discovered. She remarks that time allowed to research and organize access is very important, and can take weeks – especially if it is a matter of either trust or credibility. This can be done in advance along with practical matters (such as arranging translators, etc). Sometimes compromises are involved: for instance, the Lasné hotel is completely disused, it was only with difficulty that she persuaded the Czech municipal authorities (who were very helpful) that she really did want access to it. In the end, she had a guide and only one hour to look and take photos. She shot four films in one hour (48 exposures) working with her Hasselblad on a tripod using slow exposure and cable release, responding intuitively to what she saw and just hoping to get something good!

13 Due to an adverse and depressive reaction to anti-malarial pills while photographing Mozambique refugees in Malawi, Africa for the Red Cross and Oxfam.

14 She has been involved in setting up photography projects for patients at The Royal Bethlem and Springfield psychiatric hospitals and aims to expand this line of work. In 1999 she undertook a residency in Queen Charlotte's psychiatric hospital which is situated on the cliffs overlooking the sea at Hastings.

15 Including her visits to Australia and New Zealand.

16 Camera manipulation is crucial. The series is not primarily about space, but about discovery and examination of texture, and other detail, in particular, subtleties of colour. She shot in winter, without fill-in light, in the afternoons when the daylight would be diffuse with no strong shadows; the cool light brings out the blues in the rock. Surface also matters – she does not use projection as the effect is 'too grainy'.

17 The 'problem' of finding a title of appropriate resonance is usually only addressed at the point when a series is about to be exhibited – and is discussed with the particular exhibition curator.

18 'Littoral' refers to the shore zone between high and low tide marks.

19 It was first exhibited as a number of panels of (abstract) images relating to each day. Later she reconfigured the project for the IKON Gallery in Birmingham through pre-selecting nine streets, then visiting to pick up rubber bands as a sort of social anthropological investigation. When working similarly on Bristol Ridgeway there was one street with no bands; each house had a long drive so the post was delivered by van.

BIOGRAPHICAL NOTES

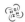

ÅSA ANDERSSON, born Stockholm, Sweden, 1965; studied art history and printmaking in Stockholm before undertaking an MA in Fine Art, followed by a PhD in Fine Art and Philosophy at Staffordshire University. She has exhibited widely, including shows in the UK, Europe, America and China. Her work explores issues of identity and perception through theory and practice, employing diverse means, including object-making, photography, printmaking, text and site-specific installations.

MICHELLE ATHERTON, born Manchester, 1967; gained a BA Hons in the History of Art and Design, from Leicester Polytechnic, followed by a BA (Hons) in Fine Art, from Sheffield Hallam University. Her work has been widely exhibited and published in the UK, and frequently takes the form of site-specific installation. Informed by critical theoretical discourses around photography, her practice is based on a long-standing fascination with 'the promiscuous culture of reproduction' and 'photography's ambiguous relationship to "reality"'. She combines this practice with lecturing in photography.

DAVID BATE, born Worksop, Nottinghamshire, 1956; studied photographic arts at the Polytechnic of Central London and the social history of art at the University of Leeds (MA and PhD). He is an artist and writer, and is currently Course Leader of the MA Photographic Studies at the University of Westminster. Recent exhibitions include 'Beauty of the Horrid' at the Five Years gallery in 1998 and 'Zero Culture' at Daniele Arnaud, London, in 2000. His work has been published in *Afterimage*, *Artifice*, *Third Text*, *Creative Camera*, *Portfolio*, *Parachute* and *Camera Austria*.

STEVIE BEZENCENET, born Chalfont St. Peter, 1950; studied photography at Regent Street Polytechnic, and language, art and education (MA) at Sussex University. Lecturing since 1972, she now works with graduate students at the University of Westminster, in Design and Media Arts. Her writing on photography has been published since 1978 and she is now increasingly interested in a visual practice. She has been working with the relationship between landscape and ideology, with particular emphasis on issues of gender, space and imagination.

SIAN BONNELL, born London, 1956; studied sculpture at the Chelsea School of Art, and took an MA in Fine Art at Newcastle Polytechnic. Her work largely consists of photographs based on intimate installations and interventions made within the local landscape. She explores concepts of 'landscape' and is concerned with history, memory, time and our perceptions of beauty, the picturesque, the sublime and the ridiculous. Her work has been included in a number of group exhibitions including 'Viewfindings' (curated by Liz Wells, toured England 1994/5). Her series, 'Groundings', was shown at the Watershed Media Centre, Bristol, in 1998. Since 1991 she has lived and worked in Dorset and is a visiting lecturer at a number of colleges in the south-west, including Falmouth College of Art, Exeter College of Art and Design and the Art Institute at Bournemouth. She is co-founder of the Trace artists collective which promotes collaboration between visual and literary arts.

CATHERINE FEHILY, born Cork, Ireland, 1956; graduated from Derbyshire College of Higher Education with a BA (Hons) Photographic Studies in 1984. She has been involved in photographic education since 1986, joining the staff at Staffordshire University in 1992. She co-founded IRIS in 1993 and was appointed as Course Leader of the BA (Hons) Design: Photography course in 1997. She has exhibited photographs in the UK and Ireland and her work with IRIS has included curating exhibitions, organizing a national conference, editing publications and Internet projects.

GINA GLOVER, born London, 1945; studied fine art at Chelsea School of Art and photography at the University of Westminster. She is a photographic artist, educationalist and founder-director of Photofusion Photography Centre in south London. She has worked extensively in photojournalism and social documentary. Since the mid-nineties the themes of her work largely focus on our relationship with nature. She tries to find imagery which visually symbolizes our own complex inner thoughts in order to make sense of the world and our place in it. She runs photography workshops in psychiatric hospitals and lectures on creativity, photography and the mind.

SU GRIERSON, born Gosport, Hampshire, 1942; studied fine art at Duncan of Jordanstone, Dundee and at Glasgow School of Art (MFA, 1995). She lives in Perthshire, Scotland, and works with installation, video, photography and digital media. Her work has been widely exhibited in the UK, Europe, the USA, Australia and New Zealand. She is a member of the management committee of Glasgow Visual Arts Forum and a panel member, Artworks for Glasgow.

ROSHINI KEMPADOO born Crawley, Sussex, 1959; BA Visual Communications (West Midlands College of Higher Education), MA Photographic Studies (University of Derby). She lectures in photography and digital imaging at Napier University in Edinburgh. She lives in London but has spent ten years in the Caribbean (Barbados, Trinidad, Jamaica and Guyana). Her work has been exhibited widely in the UK and internationally and includes Internet projects. She is a member of Format women's photography agency and of Autograph, the Association of Black Photographers, who published the monograph, 'Roshini Kempadoo' in 1997.

MARTHA LANGFORD, born Ottawa, Ontario, Canada, 1953. Her forthcoming book, *Suspended Conversations: The Afterlife of Memory in Photographic Albums*, explains the amateur album as a network of photography and orality. As a Post-doctoral Fellow with the Institute for the Humanities of Simon Fraser University, she is currently researching the expression of memory in photographic art. She was the founding director of the Canadian Museum of Contemporary Photography (1985-94) where she organized numerous solo and thematic exhibitions, including 'Anima Mundi: Still Life in Britain' (1989). At the Photo 98 conference, 'Changing Views of the Landscape 2', she presented the work of Canadian, American and European artists in 'The Photographic Landscape in

Reprise' and 'What is Nationhood?'. In 1999, she was the curator of 'Interior Britannia: Richard Billingham/Anna Fox' for the Saidye Bronfman Centre and *Le Mois de la Photo* at Montreal.

ROBERTA MCGRATH, born Johnstone, Scotland, 1956; studied at Glasgow School of Art, Stourbridge College of Art and The University of Leeds. She is an associate lecturer in the theory and criticism of photography at Napier University, Edinburgh. Publications include 'Geographies of the Body and the Histories of Photography', *Camera Austria* 51/52, 1995; 'Dangerous Liaisons' in Boffin, T. and Gupta, S., (eds) *Ecstatic Antibodies* (Rivers Oram: London, 1990).

KATE MELLOR, born Stourport-on-Severn, Worcestershire, 1951; BA Photography (Manchester). She lives in Hebden Bridge, Yorkshire, where she co-founded Outsiders Photography in 1987 (with Charlie Meecham). She works freelance as a photographer and as a lecturer. Her work has been exhibited throughout the UK as well as in the USA and Hong Kong. She has been the recipient of numerous commissions and residencies and her work is held in several international collections. Publications include *Island* (Stockport: Dewi Lewis Publications, 1997) and *Unnatural History* (Rochdale Art Gallery, 1985).

KATE NEWTON, born Newton Abbot, Devon, 1967; received a joint BA (Hons) in Photography and Design History in 1995 from Staffordshire University. Since 1994 she has played a major role in the expansion and development of IRIS, curating touring exhibitions, organizing a national conference, editing publications and coordinating Internet projects. She also lectures in photographic history and theory and continues to produce her own work.

LIZ NICOL, born Merseyside, 1956; BA Creative Photography (Trent Polytechnic). She lives in Exeter, where she has worked as a lecturer in fine art photography and media arts (University of Plymouth) since 1982. Her work has been exhibited widely in the UK, as well as in Europe, and features in numerous catalogues, including 'Swinging the Lead', 1996, and 'Umbra Penumbra', 1994. She works 'at home, in a domestic space, reflecting aspects of family history and cultural history'.

JULIA PECK, born Portsmouth, 1972; BA (Hons) Photographic Studies (University of Derby, 1994). The recipient of a number of awards from East Midlands Arts, she has exhibited at a series of UK venues, at the same time as being involved in gallery-run educational projects and lecturing in photography. She was Artist in Residence at Photographers at Duckspool, Somerset, in 1998.

BRENDA PELKEY, born Kingston, Ontario, Canada, 1950; moved to Saskatchewan in 1980 where she became involved with the photographic community through The Photographers' Gallery and the magazine, *Blackflash*. In 1994 she completed her MFA at the University of Saskatchewan where she is now an Associate Professor in the Department of Art and Art History. She has exhibited throughout Canada, as well as in England, Scotland and Finland. Her works are in numerous public collections, including the Mackenzie Gallery, the Mendel Art Gallery, the Art Bank of the Canada Council, the Winnipeg Art Gallery, the Dunlop Art Gallery and the Canadian Museum of Contemporary Photography.

LOU SPENCE, born Lambourn, Berkshire, 1965; BA Photography (The London Institute: London College of Printing). She worked and travelled for several years as a

cook before turning to photography. She has exhibited in Liverpool, London and Berlin. Her work emerges from a general sense of malaise, apparent in the press and the rural community, about the British countryside's bleak future.

JOHN STATHATOS, born Athens, Greece, 1947; studied philosophy and political science at the London School of Economics. He is a London-based artist, writer and freelance curator. Publications include *The Book of Lost Cities* (London: Wigmore Fine Art, 1998) and *The Invention of Landscape* (Camera Obscura, Thessaloniki, 1996). He recently curated exhibitions including 'Image & Icon: The New Greek Photography' (Greek Ministry of Culture) and 'Fleeting Arcadias: British Landscape Photography' (Arts Council of England). He is currently working on 'The Vindication of Tlön', an international survey exhibition on photography and the fantastic for the Photosynkyria festival in February 2001.

SUE SWINGLER, born Birmingham, 1946; studied art history at Bristol University. She is a freelance curator and researcher and worked extensively with both historical material and contemporary photographers while exhibitions officer at Watershed, Bristol. Historical exhibitions include 'Harewood Exposed' (photography); 'The Yorkshire Princess' (biography); 'Views on Sydney Gardens' (art and architecture). She is currently developing 'City Space – City Flows' comprising an exhibition by Jem Southam, an archive-based, web-sited project and an interactive digital installation. She lectures on the MA in Landscape Studies, at the University of the West of England.

SALLY WATERMAN, born Isle of Wight, 1974; BA English/Design Arts (University of Plymouth), MA Image and Communication (London, Goldsmiths). She lives in London and works as archivist at Pentagram Design. Recent employment includes running photography workshops for the education department at the National Portrait Gallery and acting as director of photography for Bateau Ivre Theatre Company, London. Her work has been exhibited in the UK, Germany and the USA.

LIZ WELLS, born London, 1948; BA Sociology/Social Administration (University of Bristol), Postgraduate Diploma, Film (Polytechnic of Central London), MA Visual Culture (Bath College of Higher Education). She worked in theatre lighting for several years (1968-74) and has taught widely, most recently as a senior lecturer in film and photography-related theory at the School of Media, London College of Printing, The London Institute, and, from September 2000, in Media Arts, University of Plymouth. She has published extensively, and is editor of *Photography:A Critical Introduction* (London, New York: Routledge 1997; 2000) and *Viewfindings, Women Photographers, 'Landscape' and Environment* (Tiverton: Available Light, 1994). She is currently working on *The Photo Reader* for Routledge and researching further exhibitions exploring landscape.

We would like to thank the following people and organizations:

Staffordshire University and West Midlands Arts for their continued support of IRIS and their financial contributions to this publication; The London Institute; London College of Printing; Philippa Brewster at I.B.Tauris for her constant support, advice and enthusiasm; Maggy Milner and Jane Fletcher for their unstinting help. On behalf of Michelle Atherton: Yorkshire Arts and Sheffield Hallam University. On behalf of Liz Nicol: the University of Plymouth. On behalf of Sue Swingler: the staff of the the Royal Archives at Windsor Castle and the Victoria and Albert Museum, London, who were most helpful in the research, and the following people for their assistance and support, and permission to reproduce images from their collections: The Earl and Countess of Harewood and the Harewood House Trust; The Trustees of Wick Court Charitable Trust and Farms for City Children; Sir Philip Naylor-Leyland, Bt. John Stathatos would like to thank Brigitte Bauer, Eve Kiiler and Natassa Markidou for permission to reproduce their work.